CONTEMPORARY ART IN SOUTHERN CALIFORNIA

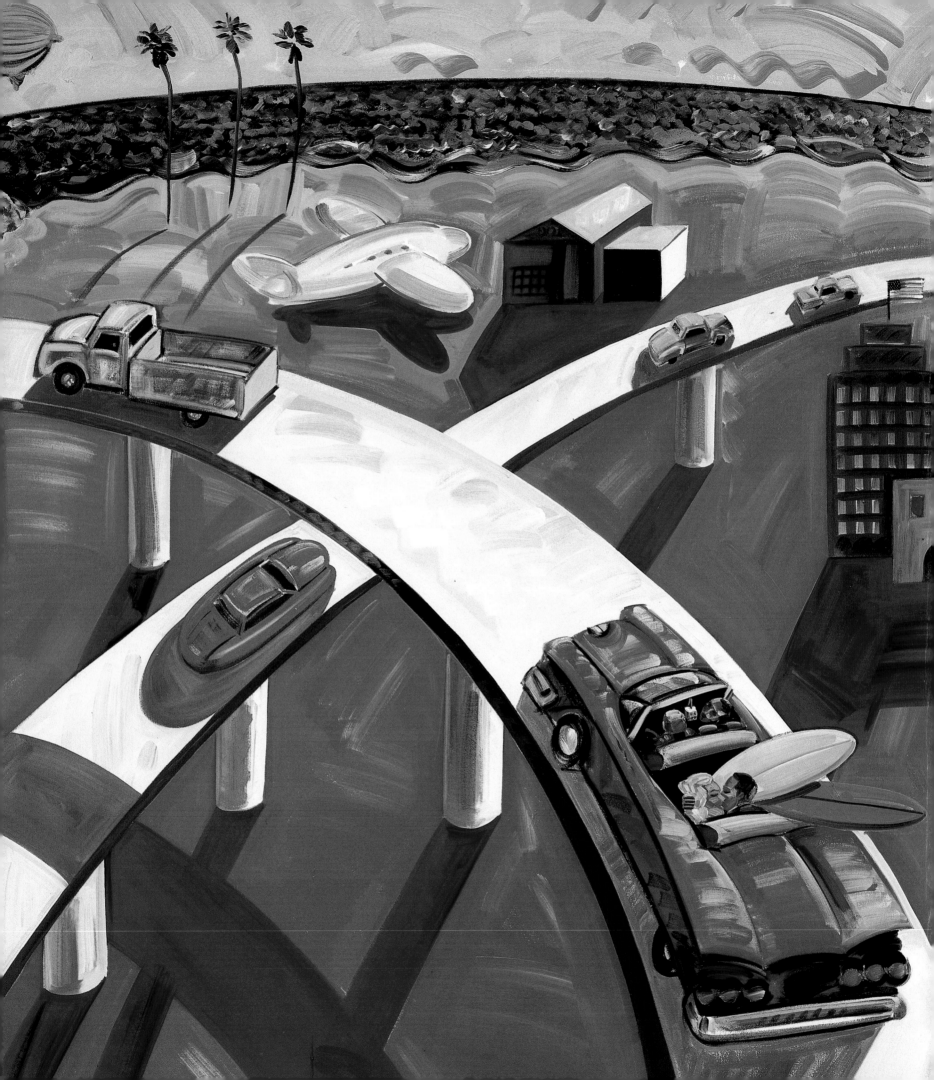

CONTEMPORARY ART IN SOUTHERN CALIFORNIA

Mark Johnstone

CRAFTSMAN HOUSE

G+B ARTS INTERNATIONAL

Introduction

Los Angeles is more than a city; it is a major controversy.[1]

For 20 years Los Angeles had been a kind of national joke — "75 villages in search of a city," they said; or, "the slag heap of Occidental civilization;" or worse. Then, one day in the 1950s, that huge, humming, uncorseted, uninhabitable town woke to discover it was turning into the cultural capital of the West. There it was, heaped high not only with works of art but with living artists … Los Angeles was where the action was, where the intellectual ferment and the wild parties and the far-out esthetic experiments could all thrive in a style reminiscent of New York after the Second World War or Paris after the First. Los Angeles had all the ingredients of a cultural explosion, but it had almost no cultural apparatus.[2]

1935. 1966. 1999. Los Angeles, like a bubbling, sputtering, primordial pool, is endlessly subsuming and reinventing itself. Impermanency permeates the *place* as if the almost invisible particulate matter floating in the air could be a catalyst for change. People are always traveling somewhere, drivers' eyes intently focused down the road as if the future can be glimpsed and arrived at, or from the passenger's seat simply watching cars and a ragged landscape of low-slung buildings, shrubbery and colored signs whiz by. The place engenders a state of perpetual tourism. Change and unpredictability are present in many places or cities, but in LA they are part of every action and the by-product of every thing, and they happen with an urgency and speed that is unparalleled elsewhere. It is the fabled Phoenix stuck in fast forward.

It is apparent that the place is unusual simply by viewing a map of it. The City of Los Angeles is an assortment of fifteen council districts that form an odd shaped jigsaw puzzle through the central basin known as the Southland, stretching from San Pedro harbor up north through downtown and over along coastal communities on the Westside, up and over the Hollywood Hills and across part of the San Fernando Valley. It is easy to blame the irregular boundary lines for many quirks of the place. In metropolitan LA (the City and County), a population of fourteen million lives and works in 4,083 square miles stitched together by 400 miles of freeway and more than 132 incorporated communities. The unpredictability and rapid change, along with overlapping spheres of influence, have created a patchwork of styles, living and works of art that, at a distance, appear as a Gordian knot.

Los Angeles in 1950 was the quintessential pre-cyber city, a collection of townships lacking mass transit and linked by roads. In 1990 the population density had swelled, and miles of landscape were filled by horizontal, usually unplanned, expansion. There is nothing "regular" to the place. A given area is likely to have a block of neighborhood houses unchanged since Raymond Chandler wrote about it in the 1940s, while around the corner is a "mini-mall" strip of stores featuring a Vietnamese restaurant, a fingernail and hair braiding parlor, liquor, videotape rentals, "swap meet" stalls selling T-shirts and sport shoes, dry cleaning or rent-to-own furniture. In many areas that 1950's sense of the localized "city" hasn't physically changed all that much; it has gone through several generations of change, possibly grown larger, is a bit worn, dirtier and more complex. Now superimpose on this map a web of computers, cellular phones, fax machines, cable television, franchise businesses, the 156 languages spoken by the citizenry, and one can begin to see how the aggregate can be bewildering, whether standing in it or observing from the outside.

Most perceptions of Los Angeles by outsiders are three to five years behind what is actually happening. Maybe it can be blamed on the idea that parts of the place are alternately solidifying and dissolving. Another possible reason is the absence of any major (mass distribution) magazines or publishing originating from the area, except for Hollywood which is adept at churning out the most simplistic self-involved ideas. Perhaps it can be blamed on the apparent lack of a cohesive history, that the story of LA

1. Harry Carr, *Los Angeles, City of Dreams*, D. Appleton-Century Company, Inc., New York, 1935, p. 3.
2. Robert Wernick, "Wars of the Instant Medicis," *Life*, vol. 61, no. 18, 28 October 1966, p. 102.

is constantly being revised just like the physical place. The history of a place is shaped by the events, people, and relationships that are chosen for scrutiny, and the multilayered nature of Los Angeles is its history. A knotted matrix of forces — commercial, economic, institutional, political — have provided important means for artists to disappear, or survive and flourish, while also providing a less direct, but more psychologically compelling influence on their lives and art.

The shifting nature of Los Angeles as *place* has had a profound effect on the shape and growth of its art scene since the Second World War. Allegiances to schools, non-profit spaces or institutions have provided the spark and support for particular kinds of work. Other types of work have received validation and support from commercial galleries and recognized institutions in New York or Europe. Beyond these separations of art and artists in the marketplace are aspects of the place that both produces and chews up things in Los Angeles. There are the masses of unusually diverse cultures such as Iranian, Hispanic, Thai, African-American, Cambodian, Russian, Chinese, Samoan, Korean, and Japanese. Throughout the city over 200 festivals take place annually. There is a climate that can be warm and lazy one week in February, when the skies clear and the snow capped mountains that ring the city can be seen forty miles away. Then there are fall mornings when a breeze floats ash on the cars, and the air is filled with the warm fear that comes with the realization that wind-whipped firestorms are blowing up the dry canyons and scrub brush hillsides. There are vast resources and economic power. The combination makes it a daunting, exhilarating, crushing, dizzy environment for life. Or, for that matter, art.

In the 1980s, along with the surge in the money supply that propelled giddy economic excesses, the Los Angeles art scene coalesced into a critical mass. Institutional support blossomed, and the structures that survived the economic downturn at the beginning of the 1990s now provide the framework for an artistic community that is tough and muscular. The skeleton, however, belongs to a beast that has never before been seen.

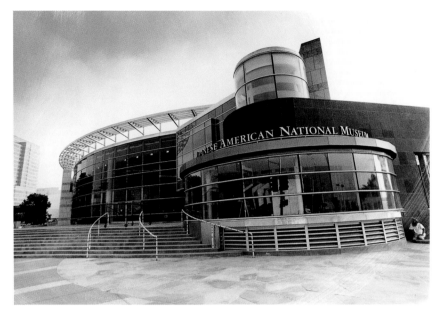

Japanese American National Museum — new pavilion
Opened January 1999, Little Tokyo, Los Angeles.
Architect: Gyo Obata, Hellmuth, Obata and Kassabaum, Inc.

Economic–Commercial

The best adjective to describe the economic and commercial climate of Los Angeles over the past ten years is "damaged." LA traveled down the same economic path as the rest of the United States in the 1980s, trailing slightly behind it. The boom that followed the 1984 Summer Olympics lasted approximately six years, and art was part of the fashionable ride. A real estate slowdown started about 1990 and, coupled with corporate downsizing, lost government contracts in the aerospace industry and an unemployment level that hit 12%, there were severe cutbacks that affected the average person's pocketbook, especially when it came to discretionary purchases in the art market. Empty office space in downtown rose to 22%, and corporate philanthropy was severely cut back.

In the 1990s LA suffered a series of colossal disasters. The 1992 burning and destruction of property in civil disturbances sparked by the "not guilty" verdicts in a Simi Valley courtroom for the white officers accused of beating African-American Rodney King, left fifty-eight dead, 2,383 injured, 17,000 arrests and $785 million in damages. Subsequently in fall 1993, major fires swept through Laguna Beach, Altadena, Malibu and the communities adjoining these three disparate locations. About 200,000 acres were destroyed, three persons killed, 159 injured, more than

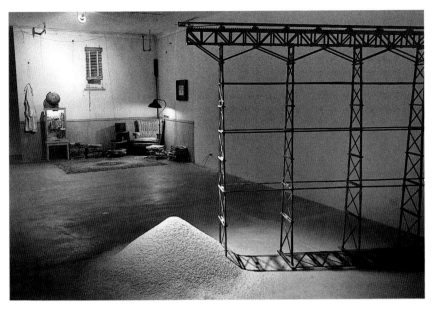

Michael C. McMillen **Train of Thought**
1990, project room installation, Security Pacific Gallery, Costa
Mesa, dimensions variable. *Photograph: Stylianos Xenakes*

1,000 homes burned and hundreds of millions of dollars in damages caused. The January 1994 Northridge 6.6 earthquake left fifty-seven dead, 7,705 injured and over $20 billion in damages. And finally, just south and slightly east of Los Angeles, prestigious Republican-led Orange County declared bankruptcy in 1995 when the $21 billion county-run investment pool collapsed in the wake of a series of highly risky and unsound stockmarket gambles.

Rioting and fires, earthquakes, Mediterranean fruit fly infestation, weeks of random, unprovoked freeway shootings, fires in the fall when the chaparral is at its driest and the Santa Ana winds blow with gusts up to fifty miles an hour, and flooding when it rains up to thirty inches in late winter and early spring are part of the *predictable* events which Angelenos endure on an annual basis.

Now, contrast these factors with the following data from one "small" industry in the area. In 1996 the estimated value of manufactured apparel shipments was $8.5 billion. LA ranked first nationally in the number of apparel employees, and is home to approximately 3,300 apparel-related businesses in the fifty-six-block downtown fashion district. Despite any travails and disasters, the city has continued to fare relatively well overall, which is a strong indication of how its resources are impressively massive and its people astonishingly resilient.

Spiritual–Political

It shouldn't be surprising that the political make-up matches the geographical and ethnic complexity of Los Angeles. As is true in many cities with populations that are culturally divergent, an overwhelming consensus of opinion is rare as what is *here* is compared to what is *there*. There are divisions between communities and among communities. A long-standing complaint has been that Westside money and power frequently favors candidates who best serve their interests, in deference to those of the black and Latino populations from the mid-city and eastern regions, or the population living on the other side of the hills — the San Fernando "Valley."

There are amazing and impressive ways that Angelenos come together on an emergency basis, and it is more than the disenfranchised grasping for an alternative to talk shows (flight is not much of a practical option for most citizens). The $9 million geodesic "FaithDome," built by the Reverend K. C. Price on Vermont Avenue in the South Central area, serves a mostly African-American congregation of 16,000, and is the largest church in America. In the wake of the 1992 riots hundreds, perhaps even thousands, of community leaders, political leaders, Hollywood stars and ordinary citizens flocked to the First AME Baptist Church to broadcast appeals through televised pulpit addresses, first for peace, then to collect goods and later for the clean-up of the destruction that had ensued.

The long mayoral reign of former police chief Tom Bradley (1972–93) during a period of slow but steady economic growth, was a fertile period introducing the liberal attitudes that were prevalent following the 1966 Watts riots. The arts steadily grew and flourished under the leadership and encouragement of the Bradley administration, even though the real political power in the City of Los Angeles government resides with the fifteen-member city council. Programs that are youth oriented and based on community involvement are the most popular (and easiest to understand) among the city politicians. The longest standing and best known of these are the mural programs of the Social and Public Art Resource Center (SPARC), under the artistic direction of Judith Baca. Since 1974, SPARC has

involved thousands of youth, community members, artists and scholars in the creation, preservation and restoration of murals city-wide. "Neighborhood Pride," through funding from the City's Cultural Affairs Department, provides for the creation of new murals and an ongoing assessment and documentation of the over 2000 murals city-wide.

Although there has been little state-wide legislative action that has directly impacted on arts in the City, political actions have played significant roles in how the public moves towards or away from support of the arts. Two key events involving city government transpired at the end of the 1980s: the hiring of Adolfo V. Nodal as General Manager of the Cultural Affairs Department in 1988, and the passage in 1989 of Percent for Art ordinances levied against both private and public development. Nodal developed a vision for the restoration of LA's historical infrastructure and anticipated the community-based needs of art programming. The public and private Percent for Art programs introduced by Councilman (and art collector) Joel Wachs proved to be the most liberally written city codes of their kind in the country. Since their implementation, between $750,000 and $1.5 million has been annually invested back into the arts as a result of these city codes. In addition, there are active public art programs under the Community Redevelopment Agency, the Metropolitan Transportation Authority, and smaller programs in many independent cities such as Burbank, Santa Monica, Manhattan Beach, Pasadena, Beverly Hills, Long Beach, Santa Barbara, San Diego and Riverside.

From the 1960s, the Los Angeles and San Francisco metropolitan areas have tended to remain liberal bastions within this conservative state. Republican governors Ronald Reagan (1960s), George Deukmajian (1980s), and Pete Wilson (1990s) set a tone that made it increasingly difficult for the arts to eke out state support. The passage of Proposition 13 (1978), rolling back property taxes, the continually Republican-led Congressional attack on the National Endowment for the Arts and a slowing economy, all contributed to significantly reduce, or entirely eliminate, state and federal support by the early 1990s. Despite these factors, and with both Bradley's and businessman Richard

Riordan's (elected mayor in 1993) support, the City's Cultural Affairs Department instituted and maintains a grants program that is funded through 1% of the City's TOT (Transient Occupancy Tax, a hotel and bed tax). This program annually awards about $3 million to all disciplines in various categories, from individuals to large budget organizations. And in the spring of 1995, directly in response to the National Endowment for the Arts being stripped of dollars and power at the federal level, the fifteen-member City of Los Angeles Council unanimously voted a declaration of LA as being "friendly to the arts."

Architectural–Institutional

Las Vegas has been touted as the most architecturally unique American city, but there are many reasons that support an argument that this "honor" is deserved by Los Angeles. Long before Las Vegas was a gambling destination, people were settling in El Pueblo de Nuestra Señora La Reina de Los Angeles de Porciúncula and avoiding the rigors of driving rainstorms, snow, ice or freezing temperatures. Consequently, beach bungalows, Craftsman houses, dingbats and Spanish colonial style duplexes are scattered throughout the city among cinder block construction, stucco slapped over plywood and Victorian-style homes. Overnight, industrial parks of concrete tilt-ups sprout up in the empty fields of long-gone manufacturing districts. Gleaming steel and reflective glass office buildings are squeezed between blocks of older, single or double-story brick commercial store-fronts. LA's tallest buildings are clustered in the business sections of Century City, on Miracle Mile or downtown. An impressive and amazing conglomeration of buildings branch out from City Hall downtown, with a significant number of post-1975 high-rises, from fifty to one hundred stories tall, mixed in with the older ten to twenty story buildings built during the past seventy years.

Angelenos were driving from work and staying home long before television began to keep people off the streets. Neighborhood populations changed generationally, and the communal bonding that once took place in the streets between people was often replaced by gangs. It has been a slow process to lure people out from their cocoons and

reverse the fractured sense of neighborhoods which permeates the City. But it is taking place, usually through clusters that are defined by several city blocks rather than entire communities. This is the specific goal of the Community Redevelopment Agency (CRA), although it has been highly criticized for its expenditure of millions of dollars, slow bureaucracy and seemingly disorganized direction. (The local "Rebuild LA" and federal "Empowerment Zones" have provided temporary assistance in the renewal and establishment of revitalized business areas.) The Cultural Affairs Department, spearheaded by the efforts of Nodal, has moved to serve youth arts and education in areas adversely impacted by recent past events. CAD recently celebrated the relighting of forty-six vintage neon signs along Wilshire Boulevard in spring 1996. The brainchild of Nodal, the "Neon Corridor," the first in a series of similar projects in other areas of the City, is an effort to both preserve a beautiful part of architectural history and to visually connect areas above the pedestrian and street pathways.

The first neon in North America was imported from Paris by LA businessman Earle C. Anthony in 1923 to advertise his Packard dealership. Wilshire Boulevard was the dominant strip of the business world. It offered sophisticated social life and was a tourist draw for Los Angeles in the 1920s and 1930s, and the beauty of art deco neon and building design delighted tourists and residents alike until the Second World War when the signs were turned off during the blackout. Recovering and preserving the architectural and artistic history is part of Nodal's goals, such as restoring the jazz scene that flourished along Central Avenue in the late 1940s, or returning crowds to the magnificent movie palaces (theaters) that still line many of the main thoroughfares of downtown LA. The second phase of extending the "Neon Corridor" is being carried out in Hollywood. Along with the preservation efforts to restore historic movie houses and buildings, it is ensuring that the sense of history that can be recovered from the past fifty years is being cared for, and slowly brought back to life in LA. The advocates of these projects know that it is possible, having rebuilt sections of Old Town Pasadena and the Third

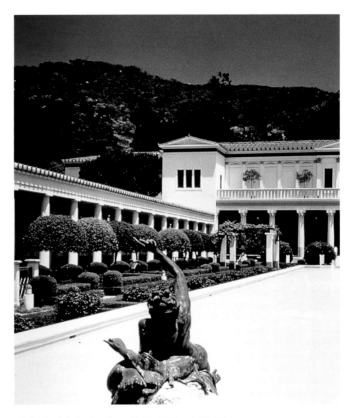

Main Peristyle Garden: Getty Villa at Malibu
© The J. Paul Getty Trust. *Photograph: Alexander Vertikoff*

Street Promenade in Santa Monica. The ongoing struggle is for a critical mass of money and businesses to back the visionary developers of downtown and other historic areas.

In 1980, the only major museum handling contemporary art was the Los Angeles County Museum of Art. LACMA, which added a Department of Photography in 1982, the Robert O. Anderson wing for contemporary art in 1986 and the Japanese Pavilion in 1988, was just another tree in the forest by 1997. The Museum of Contemporary Art (MOCA) (1984), and its accompanying Temporary Contemporary (1979; renamed the Geffen Contemporary in 1996), the Armand Hammer Museum (1990; which became UCLA at the Armand Hammer Museum of Art and Culture in 1994), and the Santa Monica Museum of Art (1988/89) have since joined LACMA and the Norton Simon Museum (formerly the Pasadena Art Museum). The J. Paul Getty Museum, which displayed its collection of art and antiquities in a resplendent recreated Roman Villa in Malibu from 1974, stunned the art world with a major acquisition of photographs from renowned private collections in 1984. The Getty is, perhaps, the major player in the world

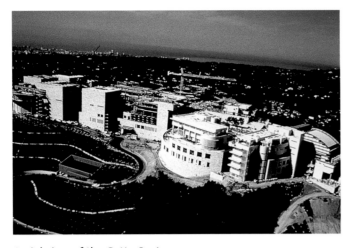

Aerial view of the Getty Center
Richard Meier & Partners, architects, © The J. Paul Getty Trust.
Photograph: Warren Aerial Photography Inc.

regarding legitimate art purchases. The new modern "castle," a billion dollar complex magnificently designed by architect Richard Meier (with a $10 million garden designed by Robert Irwin) on a twenty-four acre campus high atop the hills of Brentwood, opened to the public in December 1997. It is the best challenge that any legitimate art institution is able to mount as competition to the notion that "entertainment transcends commerce and eventually art," especially in the presence of the area's dominant entertainment theme parks: Disneyland, Universal Studios, Knotts Berry Farm and Magic Mountain.

Since 1980, many smaller institutions have continued to grow and establish loyal constituencies: Japanese American National Museum, Craft and Folk Art Museum, Carole and Barry Kaye Museum of Miniatures, Korean American Museum, Petersen Automotive Museum, Museum of Television and Radio, Museum of Jurassic Technology, Museum of Recording Arts and Sciences, Museum of Science and Industry, Natural History Museum, Autry Museum of Western Heritage, Pacific Asia Museum, Skirball Cultural Center and Museum, Museum of Tolerance, Museum of Neon Art, Japanese American Cultural and Community Center, Southwest Museum, Huntington Library Art Collections, the Armory Center for the Arts, and the Latino Museum of History, Art and Culture.

Viewing art in Southern California is about driving. East, north or south, there are numerous institutions that are both strongly supported and exhibit relevant contemporary work. A circle of culture meccas, with ever-widening rings, exists outside LA within driving distance. From the

Frederick R. Weisman Museum of Art at Pepperdine University in Malibu, 100 miles to the north, are the Santa Barbara Museum of Art and the University Art Museum of UC Santa Barbara. Sixty miles to the east are the Riverside Art Museum and the California Museum of Photography at the University of California, Riverside, and adjoining LA to the south are the University Art Museum of California State Long Beach, the Bowers Museum of Cultural Art in Santa Ana, the Long Beach Museum of Art, Orange County Museum of Art (opened 1997; a contentious merging of the Newport Harbor Art Museum and Laguna Art Museum in 1996), the University of California, Irvine, Art Gallery and the Irvine Museum. Finally, 120 miles south are the Museum of Contemporary Art, San Diego (formerly the La Jolla Museum of Art), the Museum of Photographic Arts, the California Center for the Arts in Escondido, the San Diego Museum of Art and in San Diego's Balboa Park, other institutions of art, history and culture.

Infrastructure for the Arts

It is necessary to look outside the institutional activities of the 1960s and 1970s for evidence of what artists were doing, because so little support for them existed in those venues. There was substantial support for only a few contemporary artists in the existing museum or gallery system, and high levels of activity flourished around non-profit spaces and university galleries. From the early 1960s and through the early 1970s, the most noteworthy of these non-institutional or commercial venues was the City's Municipal Art Gallery at Barnsdall Park, under the direction of Josine Ianco-Starrels. In the middle to late 1970s, workshops, classes, exhibitions, and lectures were also steadily available at The Women's Building, the Los Angeles Institute for Contemporary Art (LAICA), the Los Angeles Center for Photographic Studies (LACPS), and later the Los Angeles Contemporary Exhibitions (LACE). LACE and LACPS are the only two of this group to still be operating in 1997, and their constituencies, locations, and functions have both changed and diminished as a generation of artists has grown older and been able to benefit from a much larger pool of institutional opportunities.

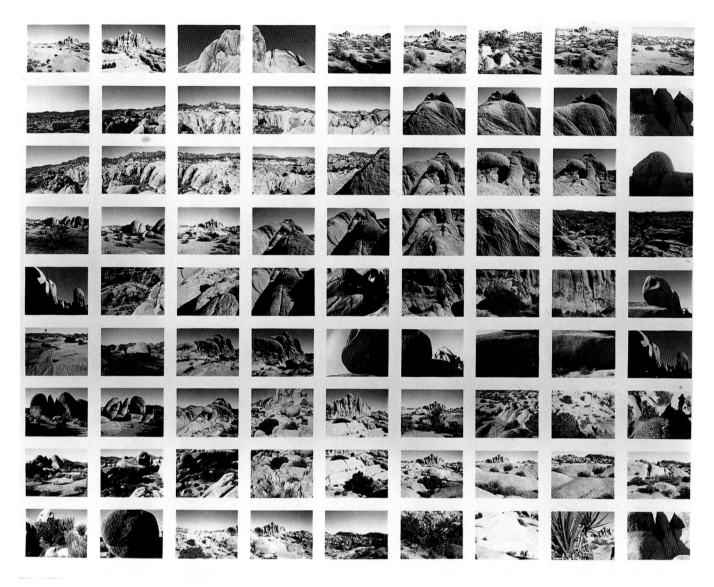

Robbert Flick **Near Live Oak, Joshua Tree National Monument, California**
1981, sequential view, black-and-white silver gelatin print. Courtesy the artist

Undoubtedly, it was the lack of any major museum presence during these years that contributed to the prominence and influence wielded by many school programs. The California Institute for the Arts (CalArts) in Valencia, offers a curriculum that still reflects its roots — Disney money — and has maintained the posture of producing some of the most successful young artists of the past twenty years (Eric Fischl, Matt Mullican, David Salle, Mike Kelley). The older Otis Art Institute has undergone a more radical revision of curriculum over the past fifteen years, and after an ill-fated marriage and divorce from

Parsons School of Design in New York, and while producing fewer recent "mega stars," has made strong moves towards adapting to the new environment. Their fashion and design program is firmly ensconced in an integral series of classrooms and offices in the heart of downtown LA's garment district. In spring 1996, the school instituted a degree major concentrating in toy design — very handy as the newly located 1997 campus is two miles from Mattel headquarters, and less than a mile from the proposed Dreamworks campus. In January 1997, at the inauguration of the new campus in Westchester, relocated from a long-

standing facility at the edge of MacArthur Park downtown, another new program was announced — "AFI at Otis," the first degree created in digital media design, that combines the resources of the American Film Institute with those of Otis. This major is intended to train artists to create special effects, CD-ROMs, World Wide Web sites and more. The Art Center College of Design in Pasadena, a national leader in the training of commercial artists, has assembled a fine arts department that is rivaling CalArts, significancy fueled by an influx of CalArts educators that fled almost en masse, at the end of the 1980s. The other schools with graduate programs — UCLA, University of Southern California, California State University, Fullerton, University of California, Irvine, the Claremont Colleges — produce an annual crop of MFA graduates who are constantly inserting themselves into the highly competitive marketplace with new work, ideas, and energy.

Several very significant and active corporate exhibition programs of contemporary work existed downtown from 1974 to 1992. Arco and the Security Pacific Galleries helped support and expose many emerging artists during a period before many of the institutions that now present contemporary work existed. Private companies like the multi-national Arco (oil), Nestle, N.A. Inc. (food products), Capital Group (investments), local businesses like O'Melveny and Myers (law), Gibson, Dunn & Crutcher (law), or private foundations such as the Eli and Edythe Broad and Lannan foundations amassed significant contemporary collections that frequently placed local work in its proper national or international context. (Broad is a private foundation closed to the public, except through appointment. Lannan ceased to collect in 1995, and set about to disburse its collection, although exhibitions continued to occur until the end of 1996.)

In the late 1960s, the primary concentration of galleries was on La Cienega Boulevard, scattered among antique stores, book sellers and a few blocks north of "restaurant row." Monday night "Art Walks" attracted crowds to the open galleries, and art galleries spread into the adjoining West Hollywood area. The La Cienega strip was still the primary place for commercial gallery space through the

1970s. Then, cheap empty space downtown attracted droves of artists in the early 1980s, and there was an accompanying relocation of galleries — and real estate speculators. The opening of the Museum of Contemporary Art's Temporary Contemporary in a Frank Gehry designed warehouse space (1979) sparked much of this new downtown action, but it only flourished briefly for two or three years, although several large artist colonies and buildings continue to exist. Since then, there have been other reincarnations of the commercial gallery scene. Los Angeles, in a speedy manner unmatched by any other major city in the world, has wholesale relocation of galleries and artist studios from one area to another simply on the basis of cheaper rents. After downtown, the boulevards of La Brea and Melrose were popular for a period of time, and then a number of galleries clustered on Colorado Boulevard in Santa Monica. The most recent manifestation has been Bergamot Station (1994), a series of warehouse buildings on an old Trolley Car Station and unused light rail storage facility. At present, this art village, complete with a half dozen architecture firms, framing service, cafe, over twenty art galleries and the Santa Monica Museum of Art (opened spring 1998) is the most congealed manifestation of an LA art district.

A core group of important commercial dealers have survived and helped shape the art scene. Since the closure of Ferus Gallery (directed by Irving Blum) in the late 1960s, Margo Leavin (1970) has directed the longest running gallery that has been continually open and consistently exhibiting blue chip work. Since the mid to late 1970s, Rosamund Felsen, Peter Gould (L.A. Louver), Jack Rutberg, G. Ray Hawkins, Louis Stern, Patricia Faure, Doug Crismass (ACE), have all managed to survive, each in his or her own inimitable fashion, and have also provided important support for the introduction of art of world significance to Los Angeles.

Los Angeles has always lacked the publishing and commercial markets that provide education and widespread public awareness. The *Los Angeles Times* is the only remaining major daily newspaper in the city. (The last rival, the *Herald-Examiner*, closed in November 1989.) Art

publications have appeared and disappeared, and the only current publication with a significant track record (ten years) is *Art Issues*, an esoteric small press run bimonthly.

Two interesting developments coalesced in the past ten years. The first has to do with a general social and/or commercial attitude that is prevalent among the artists themselves. Twenty-five years ago, artists tended to band together by discipline. Painters hung out with other painters, socialized at exhibitions of painting, and were likely to get teaching jobs through the painters network. These cliques also existed for sculptors, photographers, and so on. This separation melted away in the 1980s, and there was increased activity among all the arts including dance, theater, design, and music. More multi-disciplinary work began to appear, much of it virtually unsaleable as temporary or installation art, but it was an important sign of conceptual maturation and the wholesale cross-fertilization and fomenting of new ideas. Young artists did not think of themselves as practitioners of a medium, but as artists who could use any tool at their disposal.

The other development came about in the late 1980s, and blossomed in the economic downturn of 1991 to 1993, when dozens of galleries closed down and opportunities to exhibit fine artwork became severely limited. Most affected artists simply spent their newly available time working in the studio. In this commercial vacuum a proliferation of off-beat galleries such as Rory Devine's TRI (1992), Tom Solomon's Garage (1988), Brian Butler's 1301 (1992–95), and Bill Radawec's domestic setting (1992) appeared and, perhaps more significantly, artist-organized exhibitions began to appear, both one-time events and short series — "Bliss" (1987–96), initiated by Gayle Barklie, Jorge Pardo and Kenneth Riddle; "Food House" (1992–94), by Leonard Bravo, Robert Gunderman, and Stephen Hartzog; "Project X" (1992, ongoing), by Stephen Berens and Ellen Birrell; "The Guest Room" (1991–92), operated by Russell Crotty and Laura Gruenther; and John O'Brien's "M*Y*T*H" series at the Brewery (1993) being a few of the more notable events. These exhibitions were a mix of younger, less established artists and solidly established mid-career artists who were set on keeping artistic dialogue alive.

These opportunities were used to experiment with ideas and place work in non-traditional venues, both of which would have been far less likely to occur in a marketplace dictated by commercial interests. This phenomenon peaked between 1992 and 1995, and although the market is slowly recovering from the doldrums suffered a few years earlier, these artist-driven events still happen with varying degrees of sophistication.

The Arts and Artists

Unlike New York, where the institutions in power have enjoyed a sixty-year (or longer) reign of power, the major museums in LA are sufficiently recent, and young enough to have had relatively little influence on contemporary trends. This factor is part of the explanation for the art that is made in LA. The other part of the explanation has been the presence of many serious and competing alternative (non-profit venues) exhibition spaces, the erratic, fashionable nature of the commercial scene, and an inability to develop a significant base of committed collectors.

LACMA has the largest number of departments and curators competing for a finite amount of space and limited fund-raising ability. It has been part of the national museum network of strategic survival that presents "blockbuster shows" since the late 1970s. These exhibitions, designed to boost attendance from new visitors and ancillary sales of gift shop goods, have included such traveling shows as "Chinese, The Great Bronze Age," 1981, and the "Treasures of Tut," 1982. LACMA has even originated some like "Richard Diebenkorn, 'Ocean Park' Series," 1978, "Works of Ed Ruscha," 1983, the "David Hockney Retrospective," 1988, "Degenerate Art," 1992, and its follow-up, "Exiles and Emigrés: The Flight of European Artists From Hitler," 1997. Once looked to by artists as the only serious museum in LA, the contemporary exhibition program at LACMA has been overly broad and devoid of any clear support of local working artists since the late 1980s.[3]

MOCA has shaped a program that alternates between an international and local focus (the museum concentrates

on art since 1945), with the additional examination of architecture and city/community planning. It tends to be more involved than LACMA on an international level, and has significantly added major mid-career European artists to its collection.[4] The museum's inaugural exhibition, "Individuals; A Selected History of Contemporary Art, 1945–1986," was an exciting mix of local, national and international work. Over the past several years, the program has been aimed at more ambitious or avant-garde work as exemplified by "Helter-Skelter — LA Art in the 1990s," 1992, and has largely been an unpredictable mix of hits and misses. MOCA has more ambitiously supported working artists, particularly those with a conceptual orientation, but has operated in a manner that appears to be oblivious towards artists outside of the Eurocentric milieu.

Some of the smaller museums, especially UCLA at the Armand Hammer Museum, have been showplaces for important contemporary traveling exhibitions that might not otherwise be seen in LA. Similarly, a consortium of exhibition spaces have mounted the closest two events in LA to a biennial survey, "LAX/92" and "LAX/94," the latter being comprised of simultaneous exhibitions at nine venues,[5] unified by a single catalogue.

Since the late 1980s, the three major public art programs in LA have provided the most interesting use of artists beyond their studio walls and outside the commercial gallery or museum systems. The Community Redevelopment Agency (CRA), an agency established by State Law to serve the redevelopment needs of the city, only operates in specifically designated areas. The CRA Art

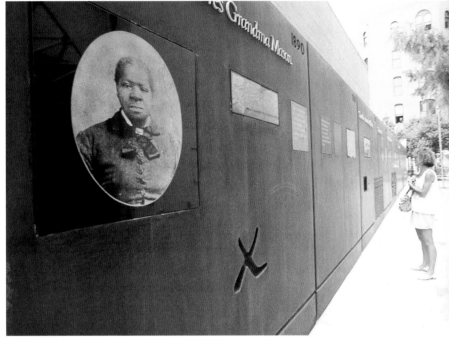

Sheila Leverant de Bretteville **Biddy Mason: Time and Place** 1990, CRA assisted public art project. *Photograph: Chris Morland*

Program is only one of many programs that serves the redevelopment mission of the agency. It has been involved in commissioning artists for major new buildings, plazas between buildings, renovations and programs in either the plazas or empty store windows of areas that need to be revitalized. Their successes are predominantly downtown: Pershing Square, California Plaza, Grand Hope Park, Bunker Hill and the Broadway Spring Center.

3. It may be attributed to the appearance of MOCA in the early 1980s; LACMA discontinued their annual "New Talent Award" in 1984. Additionally, changes in curatorial staff at both institutions seemed to slow the establishment of judicious *and* expansive curatorial tastes.

4. MOCA announced that it would receive a gift of 105 works by fifty-three artists from the Lannan Foundation at the end of January 1997. The donation, valued at more than $2 million, was specifically tailored to fit MOCA's mission and enrich the 4,000-piece collection of post-war art. In 1984, the museum purchased eighty Abstract Impressionist and Pop works from Italian collector Count Giuseppe Panza di Biumo for $11 million; sixty-seven works from the estate of Barry Lowen in 1985; a $60 million bequest of eighteen Abstract Expressionist and modern works in 1989 from collector Taft and Rita Schreiber; and a bequest of eighty-three works on paper worth $6 million from trustee Marcia Simon Weisman in 1996.

5. The nine were: The Armory Center for the Arts, California Afro–American Museum, the Fine Arts Gallery at California State University, Los Angeles, the Fisher Gallery at University of Southern California, George J. Doizaki Gallery at the Japanese American Cultural and Community Center, LACE, Los Angeles Municipal Art Gallery and Junior Arts Center Gallery, the Otis Gallery at Otis College of Art and Design and the Santa Monica Museum of Art.

Saint Vibiana's Cathedral, which was damaged along with City Hall to the point of no occupancy in the 1994 earthquake. It is where you can cruise Sunset Boulevard, ride the funicular "Angel's Flight," the world's shortest railroad, possibly glimpse the pink clad Angelyne of big blonde hair and ample bosom in her pink Corvette, or view the 10,000 year old Woman of the La Brea Tar Pits.

Los Angeles is crass with dirty streets, gutters filled with paper trash, and worn storefronts barricaded with steel bars. Los Angeles is also lush with immaculately manicured lawns and impeccably kept buildings of opulence. Los Angeles is all this on a grand scale, with everything in-between. Downtown, the seat of city government with Little Tokyo nestled next to it, is undergoing a facelift the likes of which have never been imagined in the most optimistic Beverly Hills cosmetic surgeon's office. Building on Gehry's Disney Hall will begin soon, a new NBBJ (Naramore, Bain, Brady, and Johanson) designed sports arena, to be known as the Staples Arena (after Staples Office Supplies purchased the rights for $1,000,000,) next to the Convention Center, and ground has been broken for the new Roman Catholic Cathedral designed by Rafael Moneo. Renovation has begun on City Hall. Two billion dollars worth of building and work within a one and a half mile radius. This Golden Triangle of sports, art and religion is bringing life back to an area in an unprecedented manner.

One way to define a place is by its artists, which is done by this book. There was no magic formula for how the artists were selected. I was asked to compile a group who were a significant reflection of the past ten years. It wasn't easy — there is a long list of fine artists who have been omitted from this book, and a list of fifty other names would provide another volume with a different slant — and they really shouldn't be ignored.[6]

I made a personal selection, and it involved a great many difficult decisions. Several basic questions were applied again and again to those who were considered. First, the artist had to be living. Second, had the artist produced work of national or international significance in the past ten years, 1988 to 1998? This eliminated many fine artists who are, perhaps, developing mature work, but may not have recently produced something that significantly adds to the discourse of what constitutes the LA or national art scene. It also dropped out a number of older artists whose key contributions may have waned prior to this period. Third, does this selection represent the range of work across media? It seemed important to equally represent artists working with very different kinds of materials in varying exhibition opportunities. Finally, it seemed important to include a few younger artists whose work might not be as well known, but seems no less accomplished — if this selection were to be as alive and exciting as an exhibition. Their place remains to be determined through the cycles of what will be embraced by the art world in the future.

Still others have come and gone in the past fifteen years, which makes defining the art of a place that much more difficult. Twenty years ago, there was a broader menu of survival strategies for the serious young artist after graduate school. Most MFA graduates were able to pick up a few part-time teaching assignments at one of the over thirty community colleges, four-year colleges and

6. They include: Lynn Aldrich, Martha Alf, Charles Arnoldi, David Avalos, Don Bachardy, Billy Al Bengston, Tony Berlant, Terry Braunstein, Michael Brewster, David Bunn, Jo Ann Callis, Carole Caroompas, Karen Carson, Meg Cranston, Michael Davis, Laddie John Dill, James Doolin, Jacqueline Dreager, Brad Durham, Tim Ebner, Victor Estrada, Nancy Evans, the late Bob Flanagan, Robbert Flick, Llyn Foulkes, John Frame, Steve Galloway, Harry Gamboa, Cheri Gaulke, Roberto Gil de Montes, Joe Goode, Robert Graham, Todd Gray, Phylis Green, Helen Mayer Harrison, Newton Harrison, Jacci de Hartog, Michael Hayden, Robert Heinecken, Roger Herman, George Herms, F. Scott Hess, Louis Hock, Robert Irwin, Allan Kaprow, Scott Kessler, Alfredo Jaar, Larry Johnson, Mark Lere, Joyce Lightbody, Paul McCarthy, Dan McCleary, Roy McDowell, Ed Moses, Anne Mudge, Manual Ocampo, Richard Oginz, John Okulick, Catherine Opie, the late Eric Orr, John Otterbridge, Robin Palanker, Marc Pally, Raymond Pettibone, Elliot Pinkney, Kenneth Price, Stephen Prina, Richard Posner, Ann Preston, Noah Purifoy, Susan Rankaitis, Roland Reiss, Rachel Rosenthal, Erika Rothenberg, Sandra Rowe, Alison Saar, Pauline Stella Sanchez, Mehmet Sanders, Jim Shaw, Elizabeth Sisco, Deborah Small, Thurman Statum, George Stone, May Sun, Michael Todd, Richard Turner, Kent Twitchell, Jeffrey Vallance, Patssi Valdez, Ruth Weisberg, Robert Williams, and Kim Yasuda.

universities or art schools. That marketplace disappeared by the end of the 1980s, when cutbacks in educational funding at the state level began to dramatically erode art programs, especially in the elimination of arts education at many elementary and secondary schools. (The declining funds for education are directly proportional to the rise in the prison population.) With the disappearance of these options, the more industrious (or persistent) graduates insinuated themselves into an assortment of jobs, frequently in the areas of entertainment or commercial art. The former tends to sap all one's time and energy, and the latter is not as developed in LA as New York. These are just a few of the employment reasons why a gypsy class remains in the visual arts, with art school graduates traveling to where the jobs are located. It is not like other industries whose power and interactions with the community can be clearly defined by a series of identifiable actions. Art is a profession that is primarily based on individual actions and decisions, and it is antithetical to its history to imagine that artists would ever be categorically lumped together.

California is a big state, 158,693 square miles. It is 853 miles of coastline from San Diego at the Mexican border to Crescent City near the Oregon state line. Los Angeles is the dominant presence in Southern California, as San Francisco holds a counterpart position in Northern California. Perhaps its future is best summarized thus:

> In population, Los Angeles is now the second largest metropolitan region in the United States and 11th largest in the world. Forecasters expect it will have more than 20 million people by the year 2000. The five county region, encompassing approximately a 60-mile circle centered on downtown Los Angeles, contains only 5% of California's total land area. Yet within this circle resides more than half the state's population and personal income. Fifty-six percent of the state's international trade and the headquarters for 58 of the 100 largest companies are located here. The gross product per person in the 60-mile circle ranks fourth in the world.[7]

Vitaly Komar and Alexander Melamid **Unity**
1992, Library Tower Lobby Mural, CRA assisted public art project. *Photograph: Chris Morland*

This book can only serve as an introduction to the art, a kaleidoscope pointed at the web that will blossom into different multifaceted visions with a simple twist of the barrel. "Explaining the art" is to present a single perspective that cannot convey the awe inspiring spectrum and depth of what is to be encountered. In many ways, Los Angeles can best be understood by driving the freeways. It is the space in between destinations, and like the 1970s musician and performer Lord Buckley said, "You can hear it, but you can't touch it." The artists of Los Angeles come closest to touching it.

> **But California, since we took it away from the Mexicans, has always presented itself to Americans as one of the strangest and most exotic of our adventures.**
>
> EDMUND WILSON (1895–1972)

> **You can observe a lot by watching.**
>
> YOGI BERRA

7. Michael Dear, H. Eric Schockman and Greg Hise, 1996, *Rethinking Los Angeles*, Sage Publications, Los Angeles, p. 2.

Kim **Abeles**

Kim Abeles is a modern day shaman engaged in a life-long experiment of "show and tell," navigating, exploring and charting the paths which lead to a work of art. She finds and accumulates things, asks questions, embarks on specific and open-ended searches and later reassembles or reforms everything in a poetic amalgamation of this knowledge. Her works are reflections on ideas where the assembly of seemingly disjunctive parts are shaped towards purposes for which they weren't intended, but nonetheless seem perfectly suited. She draws, sculpts, welds, sews, photographs, walks and does whatever is necessary to produce a piece.

Abeles isn't a scavenger, but a recycler. A childlike curiosity is applied with the scalpel of scholarly inquiry to the objects and ideas gathered by her. Since 1979, research has been a part of her working process, and it is in some manner incorporated into the final piece. It is through this inclusion of data collection (charting, measuring, mapping) that she is able to develop a narrative (tell a story) and develop intimate connections with a subject.

A fifteen-year survey produced the *Encyclopedia Persona*. It summarized her versatility in handling a broad range of subject matter, and the twelve series cover a "circle of learning, including the arts and sciences." Art is interdisciplinary for Abeles, as "one can never quite get a grip on what you're looking for, which is one reason for continuing." Her work involves a viewer not only with things, but also with experiences of processes and their effects, such as making discoveries about the world through assembling 265 views of smog, or harnessing it for uses that are simultaneously amusing, astounding and slightly distasteful (*Presidential Commemorative Smog Plates*). She achieves a fulcrum point where the work see-saws between the manipulation of materials and the eloquence of her message, even when the latter has a somber resonance.

The compassion and reverence in her approach to subjects is apparent in pieces about AIDS, Ethel and Julius Rosenberg and Saint Bernadette. No prevalent political or philosophical theme runs through the work, and it is neither mocking nor entirely accepting of established social systems such as religion or justice. An ability to identify a subject from multiple viewpoints (like how modes of interpretation change in the field of history), or to develop stories that bind art and activism, bring work to a human level as opposed to being based on abstract theory, and often reveal what is "behind the curtain" in her pieces.

Abeles makes works which require — and invite — repeated viewing. The ways a piece may change through repeated views, and thereby make viewers aware of the experience, is a primary strength and delight. No single piece encapsulates the range and breadth of her ideas, for widely varying subject matter indicates her interests and willingness to make a statement and take a stand.

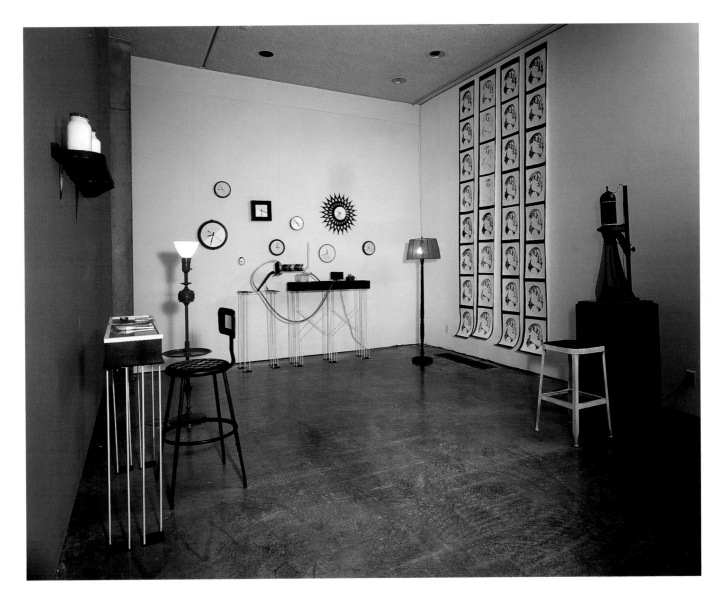

Kim Abeles **Long Exposures (An Artist in Her Later Years)**
1991–92, installation of phosphorescent paint activated by light on a relay system, welded steel, enamel, audiotape interview, water system, mixed-media objects, and photographs which combine darkroom and domestic images, 20' x 20'.
Photograph: David Familian

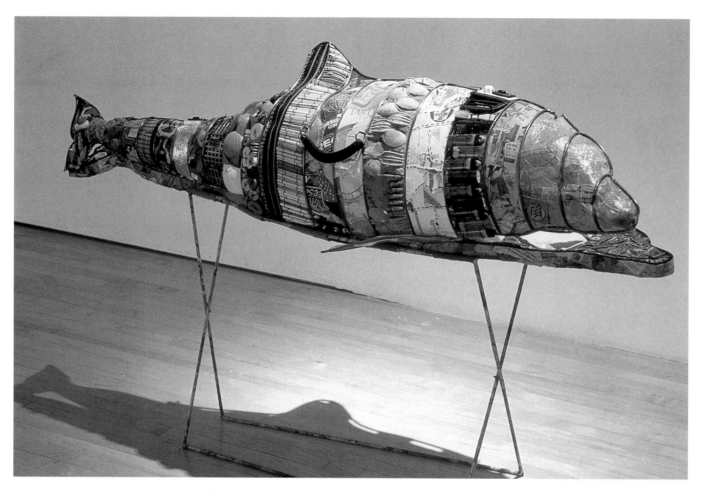

Kim Abeles **Run-off Dolphin Suitcase**
1995, beach trash, storm drain
run-off, welded steel, satin, and
mixed media, 16" x 64" x 22"

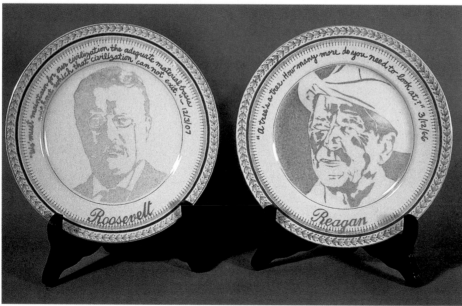

Kim Abeles **Presidential Commemorative Smog Plates (Theodore Roosevelt, Ronald Reagan)**
1992, 17 portraits of US Presidents from McKinley to Bush made of particulate matter (smog) on porcelain dinnerplates
with environmental and business quotes in gold enamel, 10½" diameter each. *Photograph: Kim Abeles*

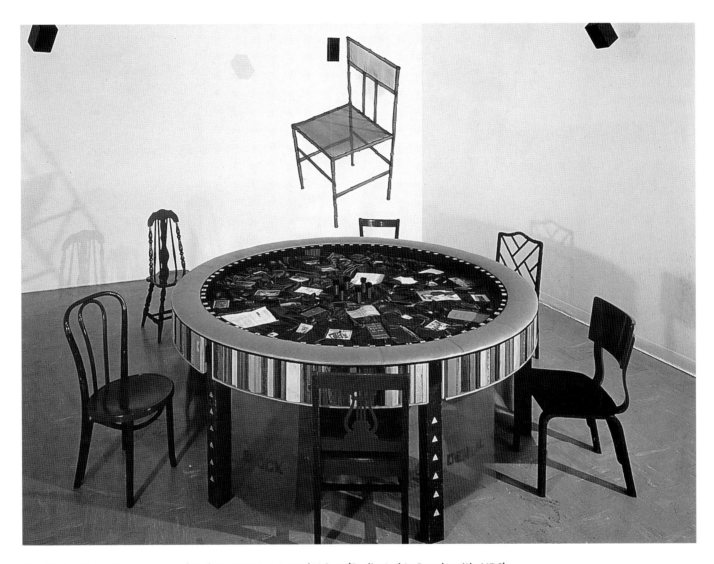

Kim Abeles, Peter Bergmann, and Barbara McBane **Found Voices (Dedicated to People with AIDS)**
1989, various items belonging to AIDS victims encased in tabletop, table and chairs made of wood,
enamels, soil, felt, and satin, table 7' diameter

Lita **Albuquerque**

Exploration and experience are the heart of Albuquerque's art, although on levels that few embrace. All humans are on a trajectory, commonly called "life," and some tend to ignore or take for granted everything but the most perfunctory functions. Others seek to achieve certain goals and then still others try to discover how this trajectory, a life, the act of being, is connected to everything else. There are no prescribed attributes for the individuals who occupy this last category, and it includes individuals from such disparate disciplines as science, religion, philosophy, and art. Lita Albuquerque, and her work, belong to this last category.

Albuquerque practices art in the same fashion that she lives life, or perhaps stated another way, she lives art as part of the life she experiences. Her thoughts and actions are constantly assessing the world, and the awareness that connects them is what informs the work that is produced. There are multi-layered physical, spiritual (psychic and ephemeral) connections to the world in her work.

She explores that journey which humans travel — and have traveled — their physical, spiritual and mystical connection to the world. Her work utilizes pure basic elements which are brought together in elegant combinations. It may take shape as powdered pigments laid out on top of desert sands, or numbers, layers and patterns of stars on a glass sheet, or the mathematical beauty of honeycombs juxtaposed between glass sheets. From a depiction of the universe encoded in the smallest particles to standing under the domed sky, breathing, stretching, meditating on the arching heavens and their scattered stars, she works the earth, ground, rocks (surface of the world) as a canvas, and conveys their essential parts into the hyperspace potentiality of her mind and studio.

Myth plays an integral part of her vision. Not the pasteurized stories of ancient tales deadened by being removed from oral tradition, but those that still live through imagination and experience. She is a locus, and that viewpoint may be transferred to a viewer, should s/he wish to assume the perspective. The awe and mystery (not knowing) of cosmological dimensions is omnipresent in her works. It is light and space and matter. It can be a simple hexagonal form, derived and based on the placement and shape of the pyramids.

In December 1996, Albuquerque traveled to Egypt to install *Sol Star*, a commissioned work for the Sixth International Cairo Biennale Festival. The project involved ninety-nine circles of 2.5 tons of ultramarine pigment scattered in a honeycomb shape on the sand of a plateau overlooking the pyramids. The installation was temporarily suspended, and international notoriety ensued, when a surveyor thought the piece held a hidden Star of David. The piece was completed when Albuquerque reconfigured it to mirror the constellations over the pyramid. It survived long enough, before being scattered by the winds, to be photographed and accompany an installation in a Cairo gallery. She hopes to return for another installation on the crowns of the Great Pyramids at the edge of the Millennium.

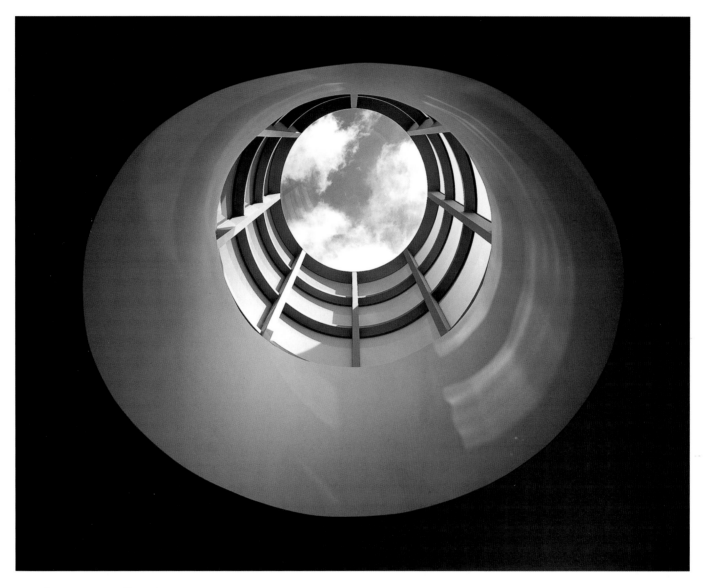

Lita Albuquerque **Stellar Axis**
1995, site-specific public art, Palos Verdes Peninsula Center Public Library, Palos Verdes, California. Upward view of 13' rooftop tower of plexiglass and steel; installation architecturally continues through four floors

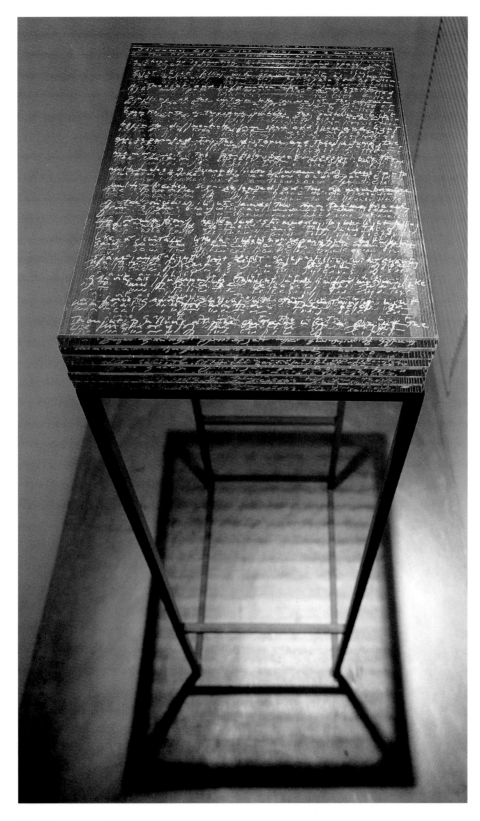

Lita Albuquerque **Particle Memory**
1995, glass, steel (layered writing on glass sheets), 14" x 11" x 44"

Lita Albuquerque **Terra Incognita**
1995, honeycomb, honey, glass and silkscreen, 30" x 30"

Peter **Alexander**

Alexander explores the romance and poetry of visual experiences, through the multi-dimensional nature of color and light. Early in his career, he became known for totemic sculptural pieces (poured resin wedges) and was frequently grouped with artists working with space and light. While his works were about the perceptually oriented experiences of light that reflected or passed through them, they were also about the position in place and time of the viewer, the emotive qualities of light and substance, and what it is to experience something from a particular vantage point.

Alexander has concentrated on two-dimensional work since the late 1970s. Different qualities of light, from effervescent, lush and sensual depictions of man-made or natural forms to blinding explosions of pure energy range through his works, as light is explored as the defining element of the tactility and translation of forms. His velvet paintings interpret space as darkness, and color as the visceral underpinnings of existence. Painted experiences of optical phenomena (as if seen from an airplane, an astral plane), or photographic bursts of light, bordering on over-exposure, create a dreamy state of transcendence, a clarity about places, events and things where light is the awakening, illuminating and transforming force.

A colorist's interest in light is present in his painted aerial views of Los Angeles from the mid 1980s. Patterns of glowing lights where things are jammed together criss-cross a slightly tilting landscape with the vaguest hint of something present in the details of their dark edges and ominous shadows. These particular images position a viewer in space. A labyrinth becomes less illogical when seen from another angle — as in a night flight over LA. A common theme that runs through Alexander's works is an acute awareness of the location of the viewer, in addition to what is happening in the visual field. It could be grossly described as "position" being a defining factor of what is seen. It is one of his levers to larger issues about perception, and the transcendent properties of visual constraints.

However often these factors are cited, the emotive side of his work is as often overlooked. The visual experience is one side, and an important one, of his work. Desire, arousal or other sensual states that emerge from his gallery and public works are the other side of the experience.

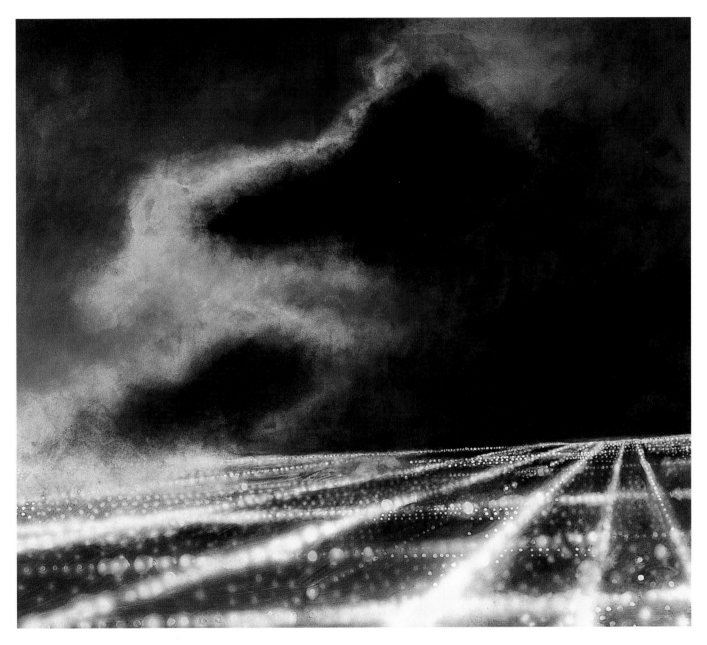

Peter Alexander **La Verne**
1989, acrylic and oil on canvas, 72" x 84". Collection: Thurston Twigg-Smith

John **Baldessari**

Baldessari has cannily crafted his work on an exploration of found photographs and for the past twenty years has assembled, shaped, and overlaid them with colored shapes or lines. Baldessari is, along with Robert Heinecken, one of the first artists to primarily base work on pre-existing images — a Duchampian, postmodern approach. He alters found movie stills and news photographs, essentially "drawing" with a pair of scissors. He is a servant to photography as media, and serves up what the act of "lifting" means (as contrasted to the act of photographing). His pieces delight in the charm of utilizing anonymous authorship to create new ideas, and affect a language of nameless effects.

The authority and essentially referential nature of photographs produced by the "camera-eye" is the basic alphabet of his work as he questions the sense of originality in an artwork by his constructions. Images are substituted for words or painted brushstrokes, and forced onto a flat field where they can be moved — but not like paint on a canvas. Still, he creates visually poetic rhythms in arrangement; a pacing achieved through the selection and sizing of images as they can be laid against the blank space of white board.

Something like a visual equivalent of the Tower of Babel exists in his cool use of photography as a reprographic medium; a viewer is aware that these are "copies," and not intended to be considered as "the real event" and, like David Lynch's film *Blue Velvet*, the works simultaneously inhabit past and present, and probe how values can be transformed in the process of recovery.

Baldessari's artistic evolution is an appropriate model for much western cultural behavior in the 1980s and 1990s. He does not observe and create like traditional painters, but strategizes like a game master. An interest in what is mundane, the "creation" of something that appears to be without style in a traditional sense, and his witty, ironic and frequently mystifying arrangements using deceptively simple images, simultaneously address the incredible boredom of things and the conceptual play that is engaged by shoppers, travelers, consumers, and art connoisseurs.

Baldessari's works effect a change in the ways viewers will perceive the world through an obfuscation and exploration of visual material. His "gestures" of assembly are both esthetic and informational; they question everything metaphysically, focus on the nature of fragmentary values and keep a viewer off balance. "Death" and "resurrection" exist in his elimination of information and reconstitution of reality: a thoroughly modern set of parables lacking any moral conclusions.

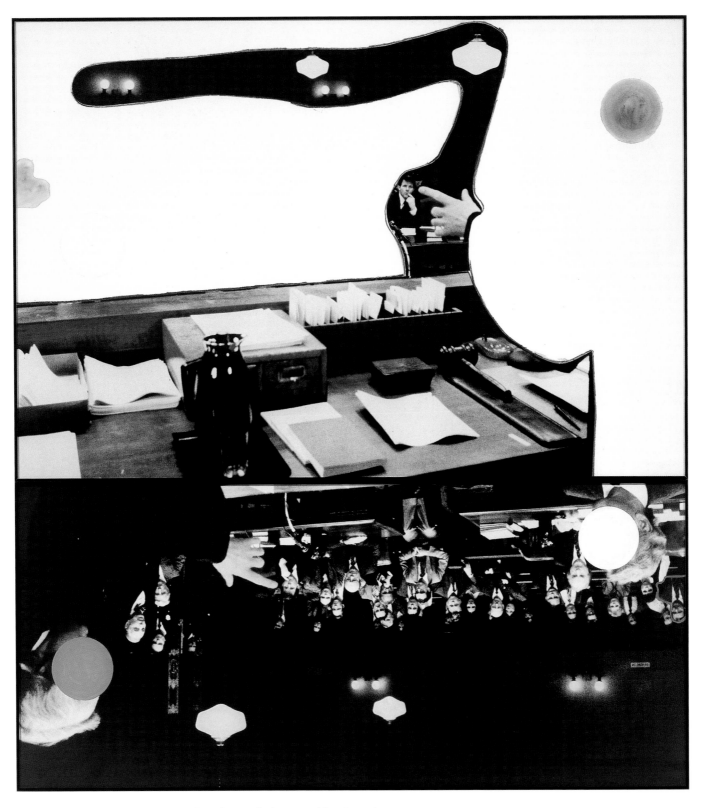

John Baldessari **Pointing Hand, Desk, Lights, and Observers (Courtroom)**
1995, black-and-white and color photographs, acrylic, oil stick, pencil on paper, 2 panels, 100½" x 90¼" overall.
Courtesy Margo Leavin Gallery, Los Angeles. *Photograph: Douglas M. Parker Studio, Los Angeles*

John Baldessari **Various Figures Dancing (with Black Shape)**
1995, black-and-white and color photographs, acrylic, oil stick, pencil on paper,
74⅛" x 48¼" framed. Courtesy Margo Leavin Gallery, Los Angeles.
Photograph: Douglas M. Parker Studio, Los Angeles

John Baldessari **Lamp, Door, Unzipped Pants (with Blue Shape and Black Outline)**
1995, black-and-white and color photographs, acrylic, pencil on paper, 80 ¼ " x 98 ¼ " framed.
Courtesy Margo Leavin Gallery, Los Angeles. *Photograph: Douglas M. Parker Studio, Los Angeles*

Uta **Barth**

The distinctions between "seeing" and "perceiving" were laid out by educator/curator/artist Nathan Lyons in a series of exhibitions at the International Museum of Photography at George Eastman House in the 1960s. (The distinction might be summarized as "seeing" being the simple act of confrontation, and "perceiving" involving understanding or cognition.) In addition, "seeing," and the implications of this particular quality of the five human senses, has a long tradition in western art of the past several centuries. Barth's works have consistently interrogated the act of seeing, and along with it the evocative poetics of perception.

The act of seeing itself is central to her work. Her earliest series of works after graduate school were about how the camera could be optically directed towards a subject. Her mature work began with *Grounds*, 1992, as subjects were rendered in an "out-of-focus" blur. Viewing is not easy, it is a strain, and it is this stretching to see, an absence of subject, that emphasizes the meaning of edges and object relationships. Light and color gain equal prominence with the subdued subject (object) matter, and the results are luminous, ephemeral and evocative.

The "Grounds" and "Field," 1995, series skillfully evoke both visceral and conceptual responses from a viewer. A viewer is "not allowed" to simply "read" an image intellectually, but is swept up in a waterfall of cascading associations that range from specific references in the history of art (amazingly enough, from Vermeer's painting to minimalism) to general, more vernacular responses (the accidental snapshot), "hey, that almost looks like …"

Abstraction, representation and romanticism are all queried by these conceptually based and rigorously "unromantic" investigations (making images through a prescribed set of actions). Her pieces are about photography, and the act of "seeing" as a container for something; a conclusion that is emphatically reinforced by presentation, as the photographic images are laminated, without borders, onto wooden frames that are designed to abruptly protrude from the plane of the white wall on which they are presented.

The creation of an aching absence is the ultimate effect of Barth's work. While pieces are physically tangible, and visually depict *something*, they affect a resonant and emotional response that is unanticipated, surprising, and unlike the usual range of viewer responses to photographs. One may muse on the work, but any musings go unanswered. One may form answers from what is known outside the work, but the work neither confirms nor denies these conclusions. In an odd fashion, they are personalized by the viewer and, even then, an awareness that one is "looking" loops the most simple observation into the dynamics of "seeing."

Uta Barth **Ground #42**
1994, color photograph on panel, 11¼" x 10½". Courtesy ACME, Santa Monica, and Tanya Bonakdar Gallery, New York

Uta Barth **Ground #38**
1994, color photograph on panel, 20" x 20". Courtesy ACME, Santa Monica, and Tanya Bonakdar Gallery, New York

Uta Barth **Field #9**
1995, color photograph on panel, 23" x 28¾". Courtesy ACME, Santa Monica, and Tanya Bonakdar Gallery, New York

Chris **Burden**

The mechanics and movement of power, both in physical and conceptual terms, underly all of Chris Burden's work. From 19 November 1971 when he had a friend shoot him with a .22 caliber rifle in the left arm from fifteen feet away (*Shoot*) to *Fist of Light* which debuted at the 1993 Whitney Biennial, he has sallied forth into the invisible forces that surround us. It may be labeled as simple curiosity or scholarly inquiry. It is both, and also a romantically extreme dance with cause and effect.

In *The Reason for the Neutron Bomb*, first installed in 1979, 50,000 nickels were each topped with a matchstick and meticulously lined up in rows. A wall text stated that "Behind the Iron Curtain along the border between Western and Eastern Europe, the Soviet Army maintains an army of 50,000 highly sophisticated tanks. The United States possesses only 10,000 tanks, and the combined tank strength of all of Western European nations, including the NATO forces is estimated to be no more than 20,000. The Western European forces are outnumbered two to one. This numerical imbalance is the reason given by our military for the existence of the neutron bomb. Each nickel and matchstick combination here represents one Russian tank."

In *Samson*, 1985, each visitor entering the museum moved through a turnstile that exerted a 100-ton jack against the bearing walls of the institution. The paradox was that a sufficiently large number of visitors would cause the destruction of the exhibiting venue. These monumental implications were condensed in *Medusa's Head*, 1990, a grimy 5-ton, post-industrial ceiling-hung lumpy spheroid, fourteen feet in diameter, replete with miniature railroad tracks, trains, bridges and vestiges of a landscape being slowly strangled; a modern object of terror.

The Other Vietnam Memorial, 1991, appears as a vertical Rolodex card file, listing the thousands of anonymous Vietnamese casualities from the *other* (communist) side of the war. Burden's works of the last fifteen-plus years are usually technically complicated, reeking of heavy industrial machinery, precisely tooled, and beautiful. His works are as unexpected and unpredictable as a lottery: The pendular sweeps of public opinion, his particular interests and conventional wisdom are all placed in a barrel, and given a big spin.

Similarly, themes of inherent power run through his most recent work, especially global politics and history. *Three Ghost Ships*, 1991, conceived for the Spoleto Festival in South Carolina and exhibited at Gagosian Gallery in Los Angeles in 1996, has three small sailboats suspended from the ceiling. They have been electronically rigged to sail without a pilot from the Atlantic seaboard of the United States to Great Britain. *L.A.P.D. Uniform*, 1993, displayed twelve 6'10" police uniforms in the wake of the 1992 Los Angeles riots. In *The Flying Steamroller*, 1996, a 12-ton Navy steamroller was suspended by chains from a central pole, around which it whirled in a strained, terrifying fashion.

The sheer scale and weight of Burden's work belongs to a new dimension of art, both literally and figuratively. The parameters of the game have been enlarged, but not without the underlying expansion of conceptual thought, without which they would ultimately fail.

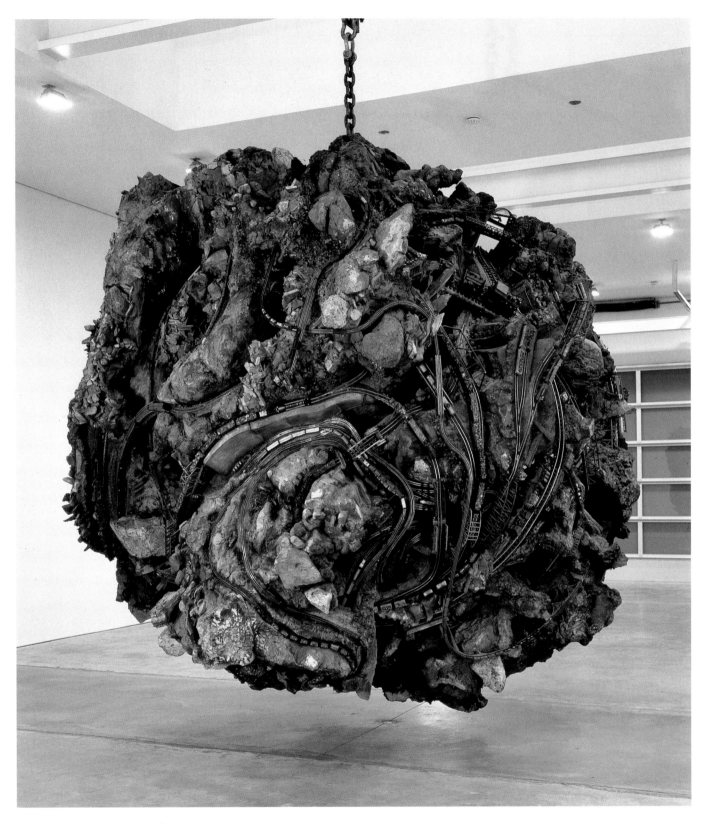

Chris Burden **Medusa's Head**
1990, mixed media, 168" x 168" x 168"

Carl **Cheng**

Rarely are the essential qualities of Cheng's work incisively, even adequately, addressed in the writings about it. The most obvious qualities are those which are identifiable (seen), that much of it is sculpture as an imprint, a physical action, and somehow these things come about through the properties of certain things that have been assembled in a particular work.

Many attempts have been made to base his work in eastern philosophy, usually for reasons of his background and/or the materials employed. These attempts have usually failed to account for some part of or development in his career, while the answer has been consistently placed in front of the public for consideration. The simple answer is that it is all the work of Carl Cheng, artist. A more complex answer involves the fact that he adroitly uses technology and nature as levers, one applied to the other, in order to discover and reveal the beautiful wonders of each.

Cheng's utilization of the world as an available space, with more options than are available in a gallery or museum, is both a choice and a direction and is based in two simple premises: The investigation and invention of art as knowledge (akin to the use of ideas by a conceptualist), and finding out how things define themselves (seeing what can be pulled out of something). Cheng is a kind of conceptualist–materialist.

More than twenty years ago, in "Erosions and Other Environmental Changes" (Baxter Art Gallery, California Institute of Technology, Pasadena, 1975), Cheng laid out his interest in the disruption that is at the heart of all the basic processes of nature. He has continued to work with these issues of temporality, making pieces for or about the North American Western Coast (using the beach, or nearby areas) which often involve time, water, earth, sand, light, and air. The movement endemic in them, however slow or fast, predicates that they cannot ever be seen in their entirety. What is always amazing about Cheng's works is their apparent simplicity, as the technological contraptions that he dreams up are tempered by quiet contemplation of the piece, or what is produced by the piece. Despite technological interventions, there really is no control for what goes on outside of a piece's inner workings; it is unanticipated and entirely wondrous. The audience is moved from passivity to activity, if only in visual appreciation or thought, as his illusions of science, mechanics and nature approximate a precision that is entirely artificial — and yet models the real world, and spiritually adds to it. Metaphors of art and the real world are made to be interchangeable, and both are the richer for it.

Carl Cheng **66% Water** (detail)
1989, installation at CAPP Street Projects, San Francisco, sand drawing, computer, electrical motors, wood, sand, water, organic materials, 20' x 35'

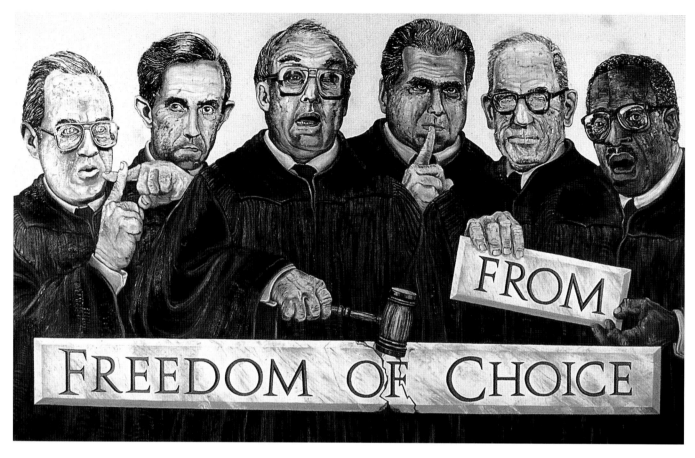

Robbie Conal **Freedom from Choice**
1994, oil on canvas, 60" x 100"

GAG ME

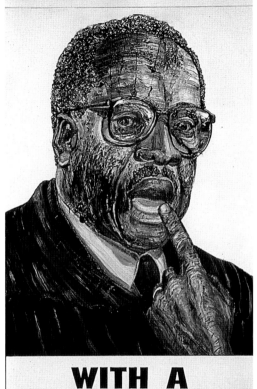

GAG ME

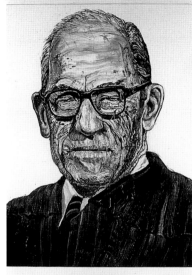

WITH

RHYTHM

GAG ME

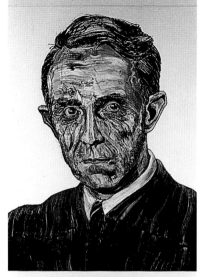

WITH

FORCEPS

WITH A

LONG DONG CONDOM

GAG ME

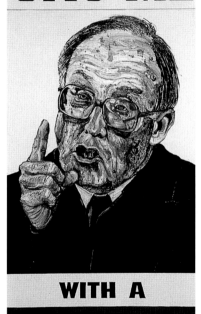

WITH A

COAT HANGER

Robbie Conal **Gag Me with a Long Dong Condom (Justice Clarence Thomas)**
1992, 3 panels, oil on canvas, 54" x 24"

Robbie Conal **Gag Me with Rhythm (Justice Byron White)**
1992, 3 panels, oil on canvas, 50" x 24"

Robbie Conal **Gag Me with Forceps (Justice David Souter)**
1992, 3 panels, oil on canvas, 50" x 24"

Robbie Conal **Gag Me with a Coathanger (Justice William Rehnquist)**
1992, 3 panels, oil on canvas, 50" x 24"

Eileen **Cowin**

The idea that a photograph can be a pictorial device with resonant emotive power, nuance or multiple interpretations, similar to the use of a word as part of a sentence or story, is an approach that is widely adopted in commercial advertising and was expanded as a conceit by many conceptual artists in the late 1960s and early 1970s. Cowin frequently draws on historical paintings, scenes from film-noir and momentary bits of news footage. These may be used as inspiration or recreated by her in a different (contemporary) context. Several formal strategies characterize her work over the past seven years, including multiple combinations of images in differing groupings (vertical, horizontal), often accompanied by a text that echoes or enlarges, but doesn't explain, the frozen emotions and actions of the images. She has also grouped still images with a slow-moving video, that is presented like the other still photographs while enlarging them with the addition of time, narrative, and movement. Most recently she has also made full-length video works. These pieces have firmly rooted her work on an enigmatic plane of existence.

The push and pull of photographs, how they encourage believability while simultaneously screaming fiction, is at the core of her work. Her use of images as partial description of a moment, thing or emotion, builds a scene in the way that a painter might visually assemble ideas. Her elaborate staging in the early 1980s pictured domesticity in contemporary American life as stills of a fictional soap opera. Since the late 1980s her works have taken on universal themes and become more resonant, both in historical and contemporary terms. They have also become more physical and cerebral. They garner greater presence through a dramatic and controlled manipulation of scale, lighting, and innovative installation, while simultaneously inducing a series of contemplative states.

Cowin carefully orchestrates her images, whether as a single scene or a series of vignettes. Her multiple-piece works owe more to the different camera movements of film such as close-up, pan, cutaway, reverse shot, and so on, than being related to traditional still photography. Her narration is not literal in the way that Duane Michals lays out series of pictures, but is like the the writing of Alain Robbe-Grillet that explored technique and thematic obsessions in his short stories between the mid 1950s and early 1960s.

Eileen Cowin and Louise Erdrich **Don't Ever Lie to Me ...**
1994, Ektacolor photograph, 44" x 48"

Eileen Cowin **Untitled, from series "Land Mines"**
1994, silver gelatin print, 11" x 28"

Eileen Cowin **Based on a True Story**
1993, installation, video with transparencies, 8' x 17' (five 12" x 17" duratrans) with 12" x 17" video monitor (bottom right)

John **Divola**

The struggle to mediate between one's mind and the world as it can be physically experienced is at the core of Divola's work. The imaginary construct of "living," and what it may mean as individual desires, is played off the observations and propositions of his photographs.

Photography is the most inexpensive and efficient available means for visual description, and it is somewhat congruent with direct (sight) experience. Divola accepts the limitations of photography as they were taught to him, essentially a nineteenth-century technology, and applies it to the world with modern ideas and endlessly surprising results. The framework for his images is his mind, and he uses the medium to express, explore and query the world through ideas.

Keen observation of how natural and man-made forces and/or powers intersect is at the core of Divola's work. His images are the correlation of how these forces manifest themselves, in specific places and at specific times, with deeper resonances. Given this chemically mediated and optically created set of observations, and how it can be made to interpret things, Divola uses it for conceptual purposes that are both statement and investigation.

He has produced bodies of work that are about the evocative gestures contained in a representation of the natural through expressionistic marks and gestures (1987–90), about the iconography of transcendence (1990), and about the classification, indexing and measuring of the world (*Seven Songbirds and a Rabbit*, 1994).

"Four Landscapes," a portfolio produced in 1993, was the same search acted out in four component parts of the indigenous Californian landscape. Produced as grainy images which suggest surveillance, solitary home structures, apparently near nothing else, appear in the empty desert spaces. Standing at beachside and scanning the ocean, solitary boats float the water far from the shoreline. In the rocks and trees of Yosemite, individuals are viewed at a great distance, seeking to commune with the sublime experience of nature, something transcendent in the Great Church of the Outdoors. These three parts observed how people try to get outside culture, escape society, and discover the sublime (which, as soon as it is grasped, is no longer sublime). The fourth part of the quartet is comprised of images of solitary dogs in the city, looking for their "natural" landscape.

Divola's most recent ongoing work features isolated structures in the high desert areas outside of Los Angeles. These images are only identified by longitude and latitude. For Divola, the drive to make art is towards something visual that transcends conventions and gains knowledge.

John Divola **N34°11.115'W116°08.399'**
1995–98, Fujicolor photograph, 30" x 30"

(clockwise from top left)

John Divola **Isolated House #4** (detail), **Boat at Sea #5** (detail), **Occupied Landscape #4** (detail), **Stray Dog #3** (detail) 1990–92, from "Four Landscapes" portfolio, black-and-white photographs, each 19" x 19"

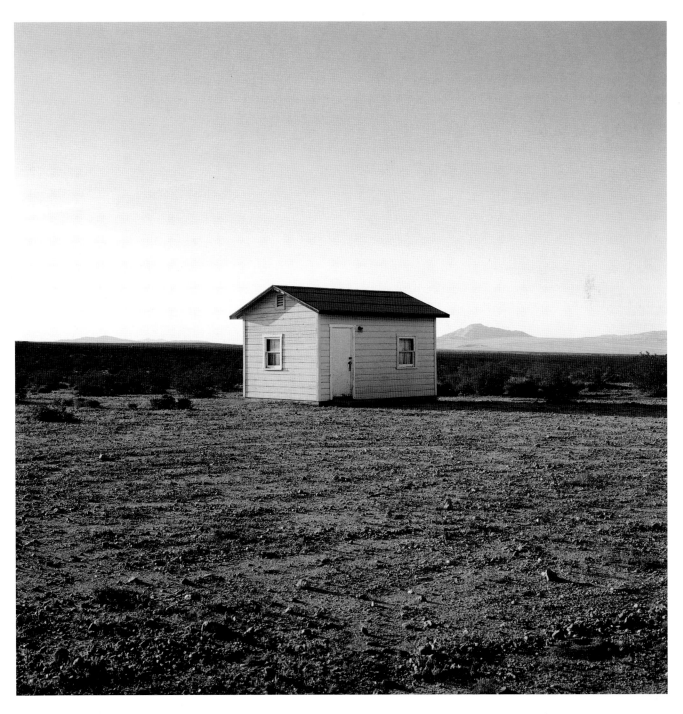

John Divola **N34°14.246'W116°09.877'**
1995–98, Fujicolor photograph, 30" x 30"

Fred **Fehlau**

In 1995 when I first visited Fehlau's studio, I was struck by the observation that there were no corners suitable for photographing or storing his work. This seemed particularly strange for an artist whose work has been largely based on orientation — both that of a viewer and the presentation of a work — where pieces have assembled corners and planes that relationally change with every new position. The theme that underlies all his work is disturbance, a dislocation or destabilizing of the viewer's gaze. The impression that emerges when viewing Fehlau's work, or speaking with him, is that of a logical order that transcends arrangement. The conclusion that later arises after an encounter with either is that subtle arrangement can transcend logic.

The ideas that run through Fehlau's works are based on an establishment of locations and boundaries, and how they can be used as a support structure for the interplay of language, surface, object, and abstract ideas. While a work may propose a certain theoretical complexity, it is likely to be presented in a simple, disarming manner that disguises layers of complex issues.

Since the early 1990s Fehlau has moved his work in seemingly different directions; however, two features which are present in all his work have become increasingly sophisticated. One is a developing skill in the language of architecture, and how it manipulates time and space. Another is Fehlau's naming of his works, which has become increasingly animated, almost poetic, some recent examples being *Alice in Wonderland*, *Deaf & Dumb*, and *Blind Trust*.

The multiplexity of his paintings, using birch panels, acrylic, aluminum, and sailcloth, challenge and manipulate viewers in their perception and understanding of the visual information. Almost nothing exists without a counterpart such as inside–outside or center–margin. Fehlau leads the viewer through a play of language to the play of surfaces, using words, defining space, and delineating a conundrum. He delights in constructing particular circumstances that will provide grist for academic and theoretical musings. His best work moves the viewer in ways that heighten a physical sense of space, as if optical experience has moved them. Safe havens, separation, doors that cannot be opened, mirrors that cannot be viewed, are strategies that he has employed in various works over the years. Perhaps his work is about something that is not there, and what is absent is important.

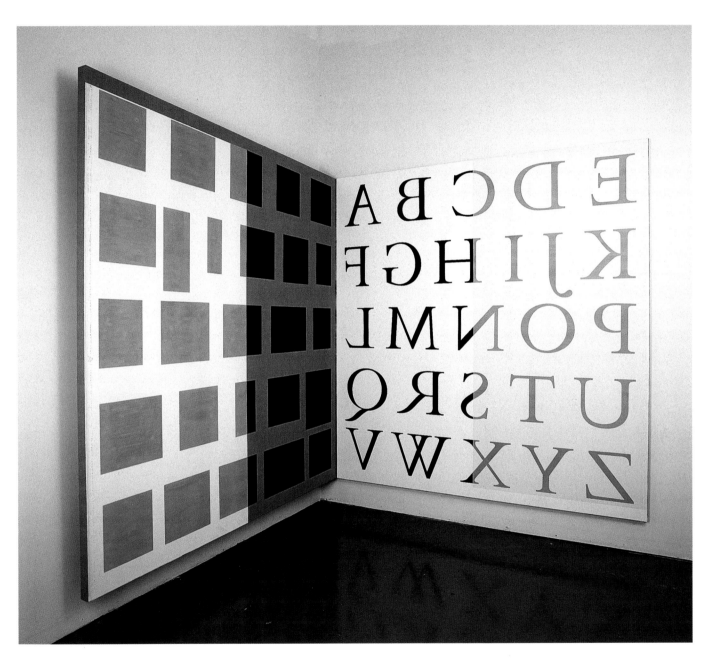

Fred Fehlau **Blind Mute**
1994, tar and oil on gesso on linen, 62" x 62" x 62"

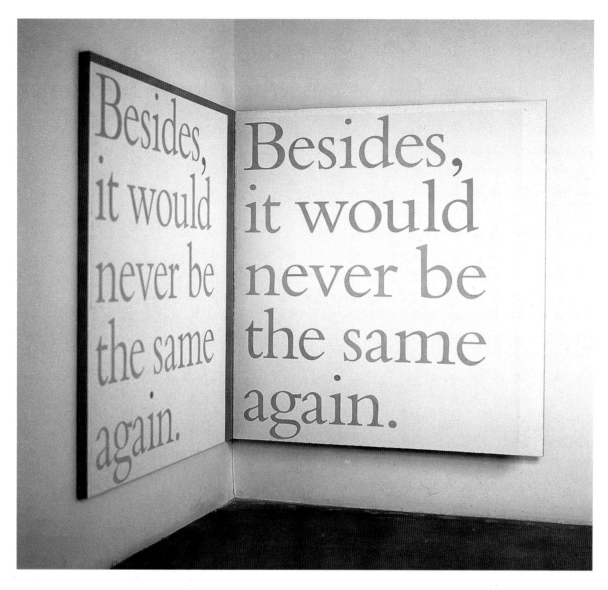

Fred Fehlau **Besides**
1993, tar and oil on gesso on linen, 44" x 44" x 44"

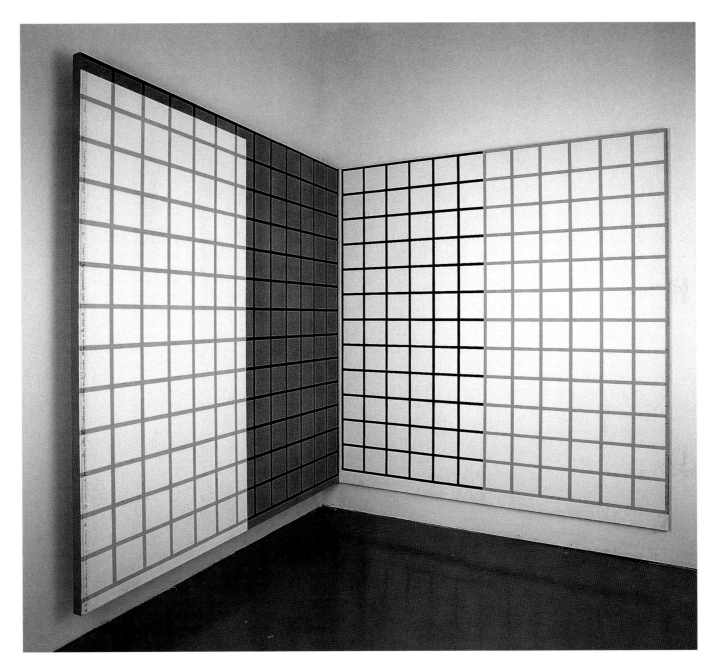

Fred Fehlau **Deaf and Dumb**
1994, tar and oil on gesso on linen, 62" x 62" x 62"

Jud **Fine**

Fine is an artist whose career has been perfect preparation for the field of public art. The paintings, drawings and sculptures he has made have always combined process and conceptual underpinnings. Massive amounts of information are evident in the work as linkages of form and the creative process.

His sculptural skills, honed in an exploration of balance and the invention of forms, have been applied to oversized paintings and works that combine painting and physical constructs. Fine liberally borrows from other cultures, both symbolically and literally (anthropologically). His use of language as a visual device (color, pattern, information as the "noise of life") has ranged far afield into the coded mapping systems of non-western European cultures, and imbued many pieces with deceptively primitive appearances which hide a sophisticated eroticism. An interest in utilitarian things rounds out his vision of art — that is, that the hand and brain are a paradigm for all art.

Fine's ongoing exploration of poles wrapped with different combinations of materials (no two are alike over twenty-plus years) is an appropriate summation, or model, for much of his other work. It seeks a narrative rhythm, one that can be disjunctive and experimental — like the sound of one hand beating on a series of improvised, primitive instruments — or it can be as smooth and sophisticated as an accomplished string quartet. Only they are visual and sculptural.

There is a wealth of message systems in his work. Drawing, painting, surface, object, space are all used to elicit the babel of voices that permeates his work. Fine plays with cacophony and sources, using symbols and signs of ritual, along with those of science and the arcane, to speak to the present.

Essentially a studio/gallery artist until the early 1980s, Fine has produced some of his most ambitious and successful work in the arena of public art. Many exterior installations, which have allowed for his manipulation of the viewer in real space and time, have brought his work to its highest level. *Spine*, 1993, created as a series of fountain pools in the front walkway at downtown Los Angeles Public Library, uses sources of information from the past to inform the present in a stunning series of tiered physical experiences. His use of convention is not part of a dialectical interrogation, but a way of rounding out the circle, another part of the multifaceted ring of life. Designed by Jud Fine and Harry Reese, *Spine* has been described as a tome about the history of written expression. There are over 180 separate elements in the work. At the public sidewalk in front of the Library, two open "covers" introduce viewers to the piece. There are four sets of steps with ascending examples of communication (hieroglyphs, cuneiform, ideograms, runes, symbols, and various languages). There are three pools that trace evolution, each with different spouts, rocks, and animals. The history of all great library fires appears on the bowl rim under one spout. (The Central Library was damaged by a catastrophic fire in 1986.)

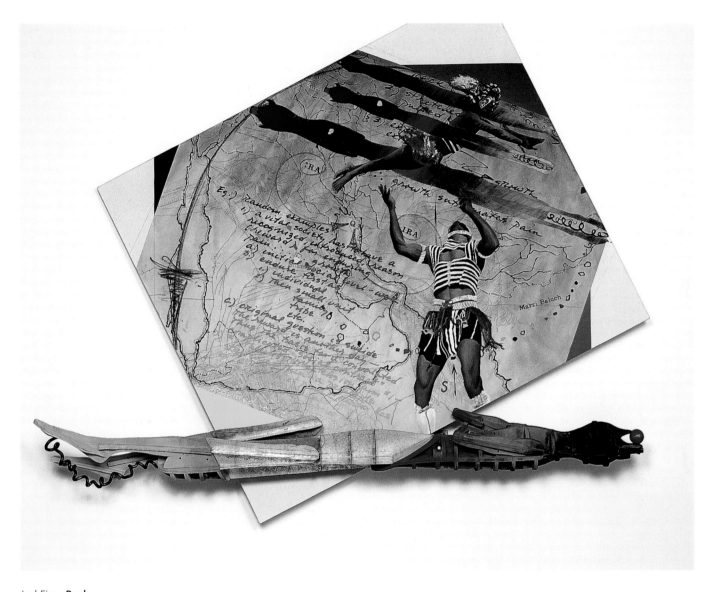

Jud Fine **Rack**
1987–88, acrylic, charcoal, pastel, pencil, ink, oil pastel on canvas with steel, wood, hydra-cal, encaustic, truss, 8' x 8' x 14".
Photograph: Douglas M. Parker Studio, Los Angeles

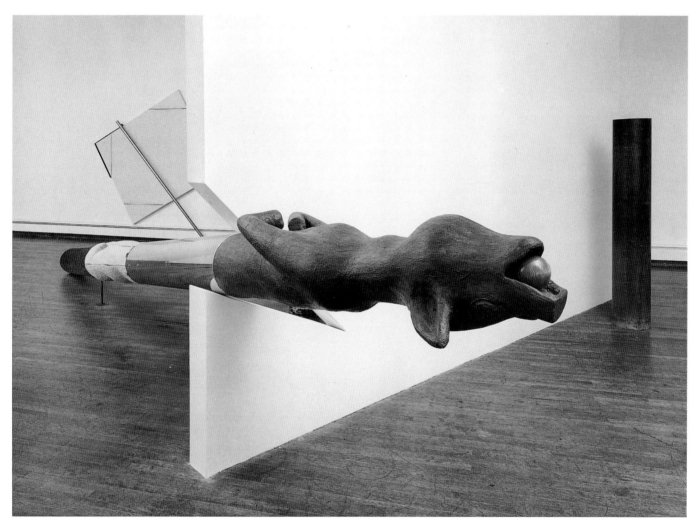

Jud Fine **Long Pig II**
1987, steel, wood, nickel-plate, hydra-cal, and encaustic, 23'4" x 12" diameter.
Courtesy the artist and Ronald Feldman Fine Arts, New York City. *Photograph: D. James Dee*

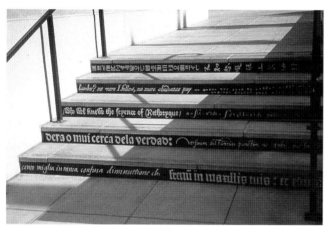

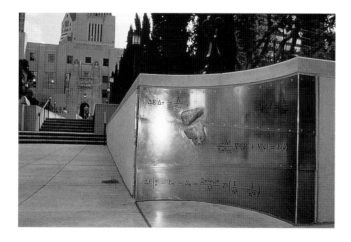

Jud Fine and Harry Reese **Spine**
1993, Los Angeles Public Library, CRA assisted public art
project. *Photograph: Chris Morland*

Judy Fiskin

The actions and activities of photography are taken very seriously by Judy Fiskin. Her work has moved from the world at large to the studio both by choice and circumstance; however, the shift has not been purely accidental, but rooted in an ideological approach to particular, selected subject matter. Fiskin is fascinated by the idea of mark making, and how it functions as visual communication or representation within the vernacular of what can be termed "common."

"Common" has more sociologically resonant implications than how it is most often used. It can be a reduction, and also a reflection or record of what informs life at a particular time and place. The series made by Fiskin at the beginning of her career (*Stucco*, 1973; *35 Views of San Bernardino*, 1974; *Military Architecture*, 1975; *The Pike*, 1980; and *Dingbat*, 1982) reduced vernacular architecture of the Los Angeles region to intimately scaled black-and-white photographs that have a conceptual similarity to the topographic photographs by the German husband and wife team, Bernd and Hilla Becher. There are major differences, as Fiskin's images are individual, small, delicate, have a sense of the bright sunlight in California, and were not produced with the same rigorous technical approach followed by the Bechers.

Her images essentially query the esthetic decisions behind the existence of this vernacular architecture in a systematic, quasi-art-historical fashion (*Stucco* — homes of the 1920s and 1930s; *The Pike* — a 1930s amusement park at ocean edge; *Dingbat* — apartment buildings of the 1950s and 1960s). When she enlarged the arena of subject matter to include craft and floral shows, museum displays of Victorian and eighteenth-century Rococo furniture, her interest in the play of esthetic judgments and cultural values that separate kitsch and high art became more apparent — *Some Aesthetic Decisions*, 1984, *Portraits of Furniture*, 1987–88, *Some Art*, 1989–90, and *Some More Art*, 1991–92.

Fiskin's fascination with popular culture and art, standards of taste and esthetics, and how judgments are translated into categories and conventions, is based on the use of photography as a lever to revealing something about these issues. The act of translation, or transformation, of the world into reduced lines, tones within a frame, encapsulates the mark making of the artist — and craftsman. Fiskin appears to take a somewhat neutral stance in this polemical argument. *Diary of a Mid-Life Crisis*, 1998, a fifteen-minute video featuring the voice of John Baldessari, is her most recent work.

Judy Fiskin **Untitled**
1994, from "More Art," nineteenth-century
American embroidery, silver gelatin print,
2⅜" x 2⅜" on 6" x 8" paper

Charles **Gaines**

The beauty that appears in Gaines' work does not stand alone, but is part of a larger systematic scheme. He has progressively constructed a set of actions which, when carried out, produce a series or set of images. They will all be different. At first glance, what is objective may sit at one end, and what is subjective at the other. Then uncertainty sets in as to which is which, and what is in-between confuses and enlarges the discussion or examination even more.

His work has consistently investigated what is objective and subjective. Logical, systematic planning is employed as a framework for subjective responses. This underlying conceptual approach provides the structure by which forms, colors, events — and meaning — take place, how what drops where, and when. A systematic delving into the way things look, coupled with the apparent and implied meanings that result, place the work in a condition (it may be beautiful, or disturbing) that is open-ended — there is no final conclusion. But what is glimpsed, thought about, or learned, can be carried away as an experience with applications elsewhere. It is one conceptualist's way for learning about knowledge and knowing.

In *Night Crimes*, 1994, there are sixteen photographs, one set of eight set over and paired with another group of eight. The top eight are news photographs, pulled from the *Los Angeles Times* picture morgue. They bluntly lay out the who, what, where, how, and other ancillary items of a crime. Each of these is coupled with a photograph of the night sky, with the date of the crime, its latitude and longitude as well as a description of the celestial alignment fifty years into the future, when the stars will again be in that same configuration.

What is produced is not particularly sensational, about facts of the crime or about astrology. They do question the patterns and forces that guide our lives in ways that we are unaware of. For Gaines, logical systems are not objective common truths, but subjective practices. He manages to find meaning as something which straddles a line between the human and the cosmic, between reality and what we think reality should look like. Like the wily fox, he sets conditions that measure how far the enterprise can be taken into what is vernacular, and possibly turn it into something slightly different.

Charles Gaines **Numbers + Trees V: Landscape #8 Orange Crow**
1988, plexiglass, photograph, silkscreen, and acrylic, 38⅝" x 46⅝" x 5½". Courtesy John Weber Gallery, New York

Charles **Garabedian**

Garabedian tends to undertake big themes in his work. Classical myths, heaven and hell. The way water is made to move. His frequently large paintings are often filled with a melange of symbols, personal and universal, some objects that are familiar and others which appear unidentifiable or bizarre.

Garabedian once stated: "I have three key words: Monumental, Archetypal, Primal." Iconoclastic should probably be added to this list, as his work is ill-suited for easy categorization. His paintings are powerful experiences that don't mirror memory or stir up realizations as much as they reshape whatever knowledge one might have had *before* they were viewed. Any sense of "knowing and expecting what a painting is about" is blown up and reassembled in a way that seems to span time and space.

There is something refreshingly "Old World" about his attitudes and work. Unable to articulate fashionably about his work process, and void of hype, he has recently set out on his own Odyssey to rediscover something of his roots, and the meanings in the ancient stories or legends that underlie everything that has happened since, but are endlessly repeated through inelegant or convoluted means — even in our own lives today.

Since Garabedian's crude figurative paintings were first exhibited in 1963, he has explored archetypal symbols, switched to decorative motifs, adopted architectural symbols, and employed cultural signs in a style that is neither purely figurative or abstract and existed long before neo-expressionism. His explorations, discoveries or revelations about the extended form, or the way color fills a space, have been almost as startling and radical as the whole piece of which they are part. Garabedian has frequently worked on a large scale (for example, some studies or paintings have measured 7' x 20' and 7' x 15'), and whatever exhilarating or peculiar qualities exist in the paintings are carried forth with a force and sheer weight that would stagger even the most naive.

Garabedian is constantly searching for pictures, and asking the question "what is a painting?" He is bemused by the notion that science or history or religion will or would explain something as complex and deep as the identity of man. Twisting explosions of color, flesh-toned wipes and blood-red weird bones, bordering on abstraction ... are we missing something? There is a palpable force present in his work, something strangely moving. Is it behind the canvas? Or emanating from it? It is something that cannot be named, but there are always those parts that haunt your memory and beckon you back to experience again, and possibly rediscover something new.

Charles Garabedian **Study for the Iliad**
1991, acrylic on paper, 46" x 46". Courtesy L.A. Louver Gallery, Los Angeles

Charles Garabedian **Phrasius, Thrasuis or Thasius**
1992, acrylic on paper, 39½" x 27¾". Courtesy L.A. Louver Gallery, Los Angeles

Charles Garabedian **Adam and Eve**
1983, acrylic on panel, 22" x 17". Courtesy L.A. Louver Gallery, Los Angeles

Jill **Giegerich**

How meaning can be conveyed through specific pictorial qualities is a theoretical starting point for Giegerich's work. Since 1983, she has parodied everyday objects, reworked shards of historical pieces and generally explored the shifting visual language of philosophical and real paradigms that constitute our conception of reality.

Ten years ago, the general leitmotif of her works was developed in industrial materials (plywood, cork, vinyl, beeswax, copper, rubber, sandpaper, brass, paint, glue, charcoal), and objects were outlined in a collapsed three-dimensional illusion. These pieces took the building blocks of modernism, excerpted details from Cubism and Constructivism, and queried these canons of historical representation. The wall reliefs and constructions that she has created are not exactly painting, nor are they sculpture in their fixation to walls. There are shifting levels of reality and perception, as trompe-l'oeil is played out in both the combination of materials and her physical working of surfaces. Historical anecdote is contrasted with the presence of "objects," and an otherwise mundane collection of pre-industrial objects (candles, candlesticks, wheels, kettles) are invigorated by her incised lines and the odd configurations that form the borders of the pieces.

Her richly textured and somewhat allusive wall constructions have progressively deconstructed representation and convention, vacillating between obscure reference and high art fetish. The architectural details that appear in some pieces are quite deadened when contrasted with the often lively subject matter of painting. It is through an adoption of industrial materials common to prefabrication that the meaning and signifying power of specific pictorial elements are examined. She reworks the mythology of modernism, probing sources both esthetic and manufactured, that are common to the artisan. The artist, then, is positioned as builder and assembler, not the creator of classic art tradition. Like the elusive puffs of smoke or steam which have appeared in her work, oblique or confrontational excavations of the past are transformed into the present and hang in their frozen arrangement — awaiting the conceptual, mindful activity that will create purpose and meaning, and derive something from the work.

Jill Giegerich **Untitled**
1993, synthetic carpet with lead on plywood, 58" x 55"

Jill Giegerich **Untitled**
1990, photocopy, shellac, rubber, and enamel on plywood, 42" x 33"

Jill Giegerich **Untitled**
1990, resinate sandpaper, rubber, copper, brass, and photocopy on plywood, 59¾" x 47⅛" x 13½"

Lawrence **Gipe**

While Gipe's paintings are typically based on visual themes of landscape or old photographs, nostalgia is an issue that hardly interests him. Whichever device he selects (such as old photographs) is a trigger into the past, a springboard for his exploration of political, social and, ultimately, humanistic meaning in the world. It is a re-examination of history as it is commonly understood. History, for Gipe, is not something immovable in recent past consciousness, but is part of who we are — and as such, needs to be closely measured, examined and constantly re-evaluated.

His paintings dive into memory and posit information; they may cause serious reconsideration about industry, governments and the motivations behind capitalism in the 1930s and 1940s. His landscapes are industrial concerns for, after all, that is the natural landscape of mid-twentieth century western civilization. The recovery of past values to the present is not only carried through the image, but also through words. What symbolically survives in an image is measured and judged by the words which are laid over or accompany the painting. His fascination with the 1930s and 1940s is the selection of a fulcrum point in the recent history of the world, when industry failed to provide a promised Utopia for its workers; unchecked greed and evil swept across the landscape of western civilization, and the limits of human experience were shrunk, expanded, transformed — but not necessarily improved — by science.

In the late 1980s, Gipe produced a series of images of factories on oil-on-wood panels which were large, visually exciting, dark, and moody with romantic wisps and puffs of steam or smoke. However romantic they might seem at first glance, the words emblazoned across the bottom of the paintings (such as "Chimera", "Fade", "Repentance", "Faith") would cause a viewer to think twice about the scene, and induce disillusionment. "The Krupp Project", 1991, became an indictment of Alfred Krupp and the US Government that had absolved the Nazi arms manufacturer of war crimes. In "The Century of Progress Museum: The Propaganda Series", begun in 1992, Gipe tackles the Faustian pacts made between government and industry, the empire building of Henry Luce and the rosy industrial picture celebrated in the pages of his *Fortune* magazine. Advertising copy becomes propaganda under Gipe's brush, and is the lever by which he expands and explodes these moments of the past. "Lubricating the Wheels of Commerce" in red lettering is sprayed out of a steam engine drive shaft. However disturbing, Gipe's excavations and re-presentation of these moments encourages self-reflection, and urges that we use our minds and be aware — for history is now.

Lawrence Gipe **Triptych No. 1 from The Century of Progress Museum (from "The Krupp Project")**
1992, oil on panel, each 114¼" x 84⅛", overall 114¼" x 268"

Gronk

Gronk is a rough-edged, seemingly inexhaustible painter who also happens to be theatrical and entertaining. A founding member of ASCO (Spanish for loathing, disgust or nausea) in the 1970s, along with Harry Gamboa Jr, Willie Herron and Patssi Valdez, he was a participant in their multimedia performances, "instant murals" and "no movies," in which they staged theatrics in public venues which were documented. The group gained local notoriety when they signed their names on the doors of the the Los Angeles County Museum of Art one night, marking artistic "authorship/ownership" of the building because so little Latino work was being exhibited inside the institution. The group dispersed in 1984, and since then Gronk has concentrated on his painting, occasionally making monotypes and print editions.

The spontaneity of these early actions, which eschewed traditional art practice, venues and art world accommodations, have survived and been refined in Gronk's personal work, which has consistently explored the edges of art. Experimentation is almost expected in his work and, while creating within the parameters of any given moment ("now"), it is frequently directed toward excavating particular themes and ideas that have resonance in the recent history of art, especially Latino art and culture.

He derives the performance aspect of his work from the traditional "work on display" that accompanies the painting of a mural, which has a particularly active heritage in Los Angeles. The muralist begins on a white-washed wall, and creates the work while exposed to the entire community. Gronk has brought this scenario indoors, and placed the speed of execution in fast forward. (Additionally, he takes a certain amount of pleasure in legally defacing the interior walls of an institution, even though it may be temporary.) The temporality of the work is simply accepted as part of the process.

There is a metamorphosis in his work of the past twenty years, from anger to romantic decadence. Different paintings, such as *Titanic Hotel*, *Bone of Contention*, *Fascinating Slippers*, and *Hotel Senator*, increasingly sank to depths which may exist in the lower, decadent levels of city life. The individual paintings do not depict a narrative, but have visual fragments, or shards of items that were once essential and precious. A single riveting persona may appear among the loathsome outcast characters. This is classic Gronk, the raw, energetic celebration of sordid romance, executed with an operatic flourish.

In the past several years, he has moved his work into new areas. He has painted on stage with the Kronos String Quartet, and made set designs for several different companies and productions, including the Los Angeles Opera Company.

Gronk **8th (Street)**
1992, acrylic and oil pastel on canvas, 72" x 54". Courtesy Daniel Saxon Gallery, Los Angeles

D. J. Hall

Women are the predominant subject of Hall's paintings from the mid 1970s. The images are not strict photorealism, although based on photographs, as she takes liberties to expand, combine and fabricate different moments or viewpoints into a single painting. Her clean colors and meticulous technique that removes any hint of brushstrokes imbue them with a kind of "hyper-realism" or, expressed another way, they depict another dimension that is slightly different from what is ordinarily experienced on this planet.

Her figures exude a confident power, whether real or a facade, as if celebrating their status and position in life. These people are at poolside or the beach, secure and safe havens from the demands and responsibilities of everyday life. Indeed, there are many suggestions of momentous observance in the different scenes of leisure, as there are drinks, cakes and other hints of celebratory indulgence.

Despite all these supportive trappings, there is an emotional neutrality to the figures and scenes, even when women broadly grin with toothy, dentally perfect smiles. The bright sunlight beats down on weathered skin and color-saturated leisure wear; that confident facade of power fades, and shifts into shades of nostalgia and loss. What initially may have appeared to be power now seems to be desperate attempts to hold onto youth, clinging to beauty with the fears that accompany aging.

In addition to oil on canvas, Hall has worked extensively with colored pencil on paper and gouache. There is a different kind of freedom present in a group of unpeopled still-life studies. Predictably, they are neatly constructed pictures of longing that don't expand as much as they luxuriate in a moment of suspended time. There is a shift in focus from the sometimes biting, incisive analysis of her earlier paintings, where these still lifes are musings on momentary beauty, with a resolve for respecting the observation — as it is. It is also clear that, while the subjects are plants or glasses or foods on small tabletops, the underlying love and focus of her work is color and light.

D. J. Hall **Shimmer — Summer Evening, Palm Springs**
1993, gouache, 8" x 6"

Tim **Hawkinson**

awkinson is the quintessential unpredictable artist in an unfamiliar world, creating art out of the most astounding and outlandish materials and subjects. His work often appears to be the product of Mr Wizard, the Saturday morning television scientist, gone amok in a laboratory that happens to border an art studio. The blend of fantasy and reality (after all, this is real stuff) produces the wonderment and heady appreciation that art is supposed to deliver. Big balloons, string, motors, and wheezing pumps offer a theatrical, almost sideshow, dimension for many of the pieces. His work is always startling in a "gee whiz" fashion that makes it a delight to look at and will immediately set a viewer's mind to thinking.

Hawkinson's work is constantly refreshing in its simplicity and lack of pretension. One imagines that he must have enjoyed making these pieces, no matter how laborious or exacting the process may have been. The magic isn't hidden, it is in plain sight, and herein lies part of their charm, for things are used for purposes that can hardly be believed. Consequently, his works carry the thrill of danger, of diving into unexplored territory through very familiar materials and technology.

Periodically he returns to his body as subject, and when he does there is some new twist, another different way that materials and perspective are used to enlarge, change and add to an understanding of both perception — and something that is usually taken for granted — the human body. What is more original than your own body? Now, what do you do with it?

He uses his body like that of an animal in an experimental test laboratory. Whether a cast latex balloon of his entire body in *Balloon Self-Portrait*, 1993, oddly bulging upon inflation, or *Humongolous*, 1995, a colored cartographic rendering of all he could see of his flesh, mapped block by block, Hawkinson retains the same dumb dignity as if he is simply another studio prop. This, in and of itself, is interesting.

For Hawkinson, what is discarded by others may become the key to the creation of a piece. If he makes a timepiece, it will not be like any other that you have ever seen. Stuff moves in many of his works, in the strangest of ways. Shrinking, enlarging, he is always messing with scale and perception. The simplicity, elegance, and directness of his efforts are not diminished at any point, in any way. It is original and highly creative work.

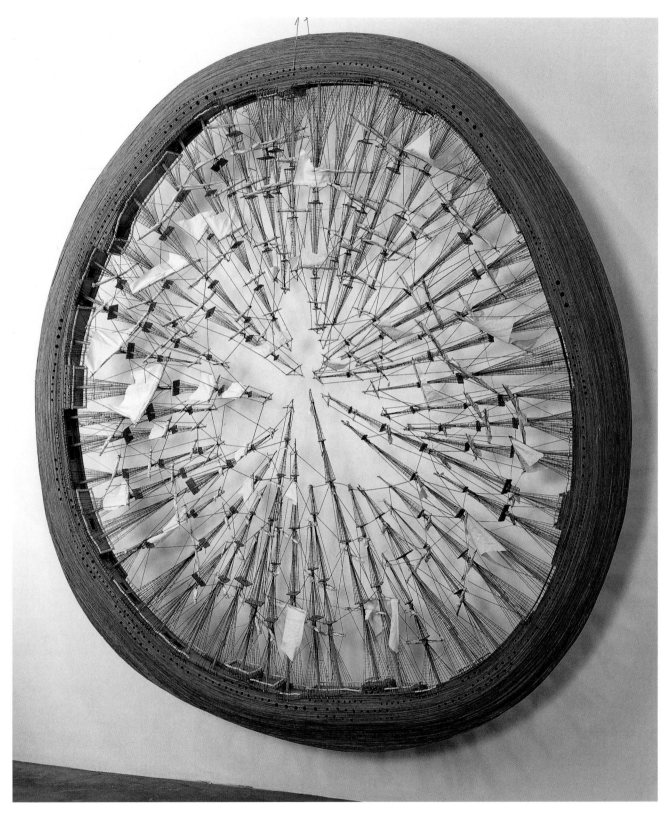

Tim Hawkinson **H.M.S.O.**
1995, wood, fabric, and string, 7'6" diameter x 10". Courtesy ACE Contemporary Exhibitions, Los Angeles

Anthony **Hernandez**

ernandez has been seriously making photographs for all of his adult life, and the various subjects he has photographically explored can be considered as a personal search for the place and ramifications of artistic meaning in the world. His subject matter through the 1970s was the public theatre of the street, visualized in black-and-white by means of a hand-held 35 mm camera. Since the early 1980s, he has additionally worked with larger film formats and in color. This work of the past twenty years is distinctive, mature and seductively powerful. The images are often beautiful, almost serene, with sensuously rich and delicate colors which resonate with penetrating implications. This combination of dissonant qualities make his photographs some of the most powerful observations of life in North American western society and culture in the late twentieth century.

His work withholds any specific indictment of the circumstances or subject matter that is pictured. Like two sides of a coin, the images are compelling with a delicate beauty that carries a viewer farther into the pictures. There is an enigmatic stillness, a void of visual distractions, that is penetrating and almost violent in its description of reality. Whether the subjects of his work are the opulent cultural decadence of the high society, expensive shops (and shoppers) of Rodeo Drive in Beverly Hills, the detritus of target-shooting sites outside city limits, the abandoned products of a marginal social class in thrift stores, the raw nature of Idaho landscapes, or the sites for homeless hidden among the freeways of Los Angeles, the images that Hernandez makes have been thematically (almost compulsively) guided by something real and raw at the edges of American culture and society.

The sense of displacement that may be felt by a viewer upon encountering his work is a product of his vision that will set one's moral compass wildly spinning. His observations are from an immersed, intimate connection with the subject matter — confrontations that are both charged with beauty and the larger consequences or implications of what it means to be an individual in this society.

There is a physical reality to the pictures of Hernandez that represents the best and most powerful qualities of photography as an artistic medium. There are also underlying meanings which are as heaving, brilliantly incisive and historically grounded as any contemporary conceptual art. His work covers categories that might appear presumptuous on paper: Land Art, Social Art, Descriptive Art and/or Humanistic Art. His subjects are neither sexy nor glamorous, but with his work in color those dimensions emerge in the way his subjects are pictured. Still, these photographs are genuine with a direct simplicity, and therein lies their power — and truth.

Anthony Hernandez **Landscapes for the Homeless**
1988, Cibachrome, 30" x 30". Courtesy Dan Bernier Gallery, Los Angeles

David **Hockney**

Hockney may be the most well-known artist in the world today. So much has been written about him that an attempt to write something significant in five or six hundred words seems depressingly futile. Instead, notations about specific accomplishments will be listed; these may be, or might relate or refer to, salient features in his work.

A. Adventuresome. He directed the opera *Tristan and Isolde* in 1997, ten years after the debut of the LA production that gained considerable attention through his special lighting, sets, bold colors and fanciful shapes.

B-1. British. It is hard to tell whether the British admire or loathe him. After all, he is the shining example of the Great British Artist at the end of the twentieth century, but he gained his reputation as an expatriate of over twenty-five years in that crass, sun-drenched movie city — Los Angeles.

B-2. Baseball caps. He wears them. It is hard to say whether they are simply billed designer caps worn for fashion or whether they are intended to demonstrate loyal fan support of something.

C. Canvas. Color. He accepts the immutablity of a line on canvas in space, and is keenly aware of how an addition of color will transform or compound that moment. (See A.)

D-1. Drawing. It is his exercise to achieve the eloquence of a gesture that has orchestral overtones. (Reference: Japanese master calligraphy, also Richard Wagner, German composer; see A.)

D-2. Dogs. He likes them, and his dachshunds have occupied a special place in his life.

L. Light. Long ago he was struck by the special light and sensibility that is the make-up of the LA landscape. His paintings and drawings are about appearances, in that he is "looking at the subject, and not so interested in taking things apart." (See T.)

P-1. Photocollage. *Pearblossom Hwy., 11–18th April 1986 #2*, a 6' x 9' mosaic of 750 color photographs, the culminating work in a four-year period of experimenting with photography, was purchased by the J. Paul Getty Museum on 7 August 1997. "Our photography collection is our window into the 20th century and the 21st century," stated museum director John Walsh in an article in the *Los Angeles Times* on 8 August 1997. Weston Naef, the museum's curator of photographs, observed that the work cost "less than a Hockney painting of comparable size, but we didn't buy it with petty cash." It is stored in a special climate- and temperature-controlled vault.

P-2. Play. There is a playful edge to many of his paintings, perhaps most evident in drawings of his dogs. (Anyone who has more than one dog, and makes them the subject of serious artistic enterprise, displays great sensitivity. Could "P" stand for "pooch"?)

T. Technology. His fascination with camera vision and faxes, strongly related to ideas about drawing and Cubism. Qualities such as one-point optical perspective (rendered from different positions), moving through space in time and the spatial relationships created by the lens contribute to his interests, not so much in how or why something works in a particular way, but the experience of how it *looks*.

X. The x factor; x being an unknown, is always present. For example, some of the paintings border on being abstract in their arrangement, and have a textured complexity. Pick a specific painting that corresponds to this description. It has the x factor.

David Hockney **Painted Standing**
1994–95, oil on canvas, 48" x 36". Courtesy L.A. Louver Gallery, Los Angeles

Margaret **Honda**

Honda's work is highly intellectualized. She defines her own terrain within which there may be hidden (physical) dangers, and presents issues of power and control by the arrangement of works within a space. Engagement is inescapable, as her work cannot be viewed (experienced, moved through) without the correlating suggestions of these abstract references. Although knowledge predicates a larger picture, it doesn't necessarily provide any or all of the answers.

In "Traps", a series of works begun in 1989, Honda played with the dualistic properties inherent in objects, materials and ideas. A viewer is able to accumulate power by gleaning the different meanings of these nineteenth-century devices used to capture or kill wild animals. The installation titled *Gift*, 1993, presented a series of small wooden boxes. The contents of each were partly obscured by sliding panels. Each box contained something different, from folded linen napkins or sterling-silver utensils to small vials of poison. The pieces force/invite viewer interaction, rather than simply existing to be observed. There is a transmission of knowledge, along with the presence of Honda's control and manipulation of the situation.

Recto Verso, an installation at the Museum of Contemporary Art in Los Angeles in 1994, consisted of objects related to vision and measurement. A ladder against one wall, and the folding metal rod — similar to a carpenter's ruler — heighten an awareness of the relationship between perception and spatial positioning. The installation, in fact, is related to the exercises Honda experienced as a child to correct a medical condition in one eye.

Honda's work is physical and experiential, and doesn't readily lend itself to reproduction. Like the best installation work that has emerged over the past twenty years, it is not designed for flat reproduction but physical and psychic contact. An ambivalence about existence, what is "safe" or "dangerous," is at the core of her work. The duality present in her works, as relationships are emphasized or tightened between what is predicated in the object and how it is exhibited, subtly pulls issues of culture, history and society into play. Simultaneous realities among thought, perception, experience, and history form a complex matrix whereby the physical movement of a viewer is correlated to perception.

Part sculptor, part installation artist, and entirely a conceptualist, she conjures and creates scenarios, as much as she creates pieces.

Margaret Honda **Gift**
1993, installation view, Shoshana Wayne Gallery, Santa Monica, dimensions variable

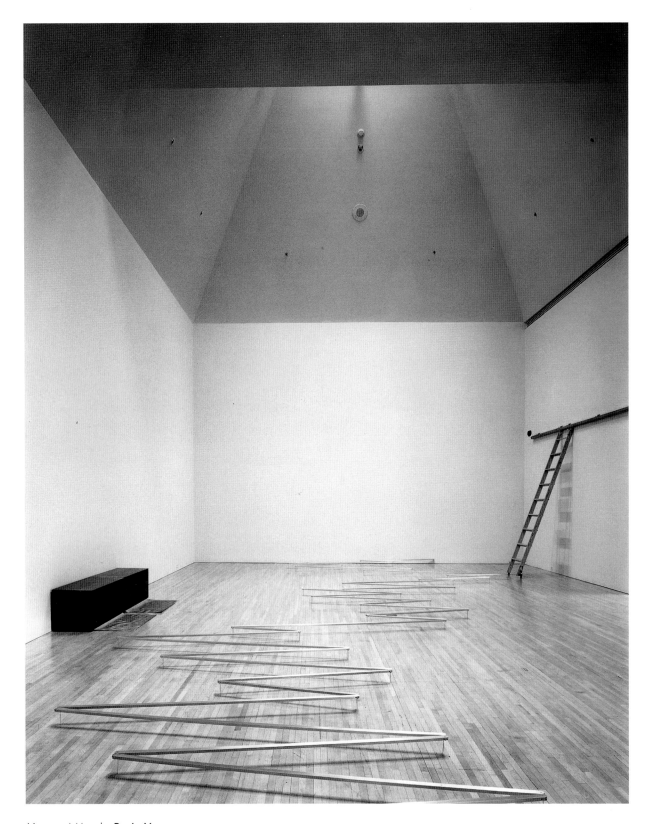

Margaret Honda **Recto Verso**
1994, installation view, dimensions variable. *Photograph: Gene Ogami*

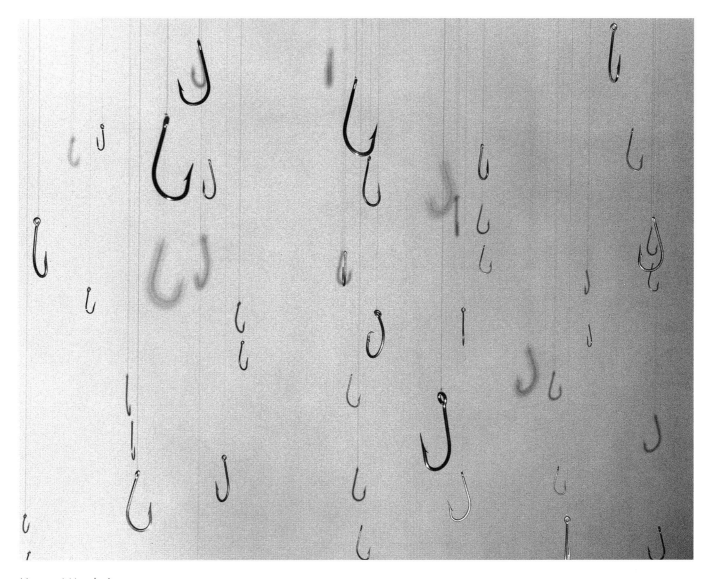

Margaret Honda **League**
1992, fish hooks, monofilament, and lights, dimensions variable

Jim **Isermann**

Isermann draws on recent past history, and accumulates visual patterns that will act both as trigger for others of similar experiences and question traditional notions of beauty, cultural meaning and art history. He mines the motifs and images of decorative pop styles from the 1950s and 1960s, rendering them into entirely appropriate, but nonetheless startling, pieces. His works are simultaneously "pretty" and crass, self-conscious of fashion and embedded within social practice, and can be somewhat problematic for mainstream notions of art.

Isermann doesn't make predicatable art in the sense of using the traditional tools and materials of most accepted "high art" forms which make their ways into galleries and museums. Rather, he has taken on crassly commercial materials, albeit with a history that is predominantly borrowed from other eras or cultures, and shaped them with specific references to both their sources and the "flavor of the day" art ideas. He has worked with motifs of flowers, explored the shape, form and color of psychedelia, and made shag-rug paintings, hand-sewn patchwork fabrics, painted furniture and abstract weavings.

Failed Ideals, 1995, his six circular stained glass and epoxy resin circles that top pylons running down the middle of an outdoor Long Beach MTA subway platform, uses the same basic conceptual approach. They are designs derived from buildings and signage in the area that no longer exist. They achieve a cross-pollination of the vernacular with public art, cultural history and "high art." (Ideals that were the cutting edge of fashion design, and now are being debunked, for whatever reasons.)

A hand-braided rug from 1996, exhibited at Richard Telles Fine Art in Los Angeles, carries the bold, colorful history of abstraction in the twentieth century onto the horizontal "sculptural" dimension of the floor. Likewise, *Cyberweave*, 1996, exhibited in "Sunshine and Noir: Art in Los Angeles, 1960–1997" at the Louisiana Museum of Modern Art in Humlebaek, Denmark, further develops this idea.

He has seized on patterns as a quasi-sociological/urban planning analysis of culture from a particular time and place, such as the linoleum squares on a floor or the abstract color patterns found in a coffee shop, and has drawn meaning from what influences, shapes, forms and contextualizes life in the most common ways.

Jim Isermann **Untitled**
1994, hand-loomed linen, 51" x 54". Courtesy the artist, Feature, New York, and Richard Telles Fine Art, Los Angeles.
Photograph: David Familian

Jim Isermann **Untitled (D)**
1991, stained glass, 36" x 36". Courtesy the artist, Feature, New York, and Richard Telles Fine Art, Los Angeles.
Photograph: David Familian

Jim Isermann **Untitled**
1993, pieced cotton and cotton-blend quilt top, 76" x 76". Courtesy the artist, Feature, New York, and Richard Telles Fine Art, Los Angeles. *Photograph: Peter Muscato*

Mike **Kelley**

Kelley is the *enfant terrible* of contemporary American art, milking and mocking the culture, and capitalizing on all the possible collective fears of institutions, history, family, and along with them, art history and education. Scatological humor, adolescent fascinations with sex, and crude and vulgar language are all employed by him to force together high and low culture, craft and art.

Kelley's works attack cultural mythology, and often employ metaphors of a "damaged" childhood (it should be noted: salvaged as art) as the renunciation of purity that might be expected from any lapsed Roman Catholic. *More Love Hours Than Can Ever Be Repaid*, 1987, is an assemblage of stuffed animals collected from thriftstores, where Kelley has sewn them together in a flowing, somewhat abstract design that parodies a Pollock drip painting. Viewed by Kelley as symbols of unrequited love, rejected by original owners and left to the thriftstores, the stuffed animals become stained with guilt.

From *The Sublime*, 1984, where rawness is so consistent that it achieves (paradoxically) a level of skillful execution, to *Craft Morphology Flow Chart*, an assortment of stuffed animals and dolls laid out like familial groupings of a biological genus, youthful promise and adult responsibility or restriction are presented in ways that eschew nostalgia or sentimentality, and require these "playful" topics to be seriously considered.

Pay for Your Pleasure, 1992, a pantheon of garish portraits of celebrated male poets, artists, philosophers and patrons, displayed with a disconcerting quote by its historically revered subject: "I think the destructive element is too much neglected in art." (Piet Mondrian); "The fact of a man being a poisoner is nothing against his prose." (Oscar Wilde). An original work of art by a convicted criminal was displayed at each exhibition venue. In Chicago it was John Wayne Gacy, a notorious serial child killer, in Los Angeles it was William Bonin, a serial killer who picked up victims on the freeways, and in Europe it was Jimmy Boyle, a Glasgow gangster. At the entrance of the installation was a contribution box, with the proceeds going to charitable organizations helping victims of violent crimes. Like so much of Kelley's work, the installation serves to question cultural and social values at large, while simultaneously bringing the same issues down to an individual personal level.

Herein lies much of the basic nature of Kelley's work. He is unashamed to use sentimentality, criminal or creative voices, push the envelope on what is sublime, propose issues of esthetics on an intellectual level, play off the collective fears of institutions, include overlooked areas of history, reveal and revel in his own cleverness. His works simultaneously milk and mock culture, and whatever trappings accompany it.

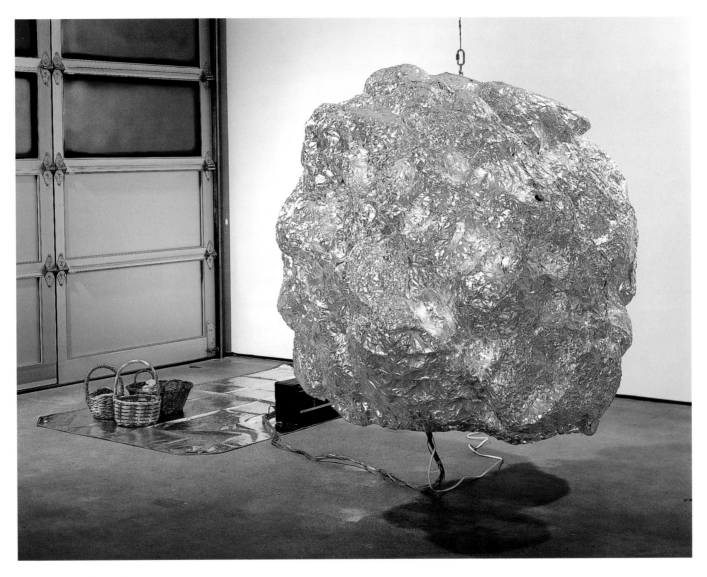

Mike Kelley **Silver Ball**
1994, aluminum foil, polyurethane foam, wood, chicken wire, speakers, 4 boom boxes suspended from ceiling with steel cable, space blanket, 3 baskets, and artificial fruit, ball 58" x 58" x 53", blanket, baskets and boom boxes, 13" x 47" x 82". Courtesy Rosamund Felsen Gallery, Los Angeles. *Photograph: Douglas M. Parker Studio, Los Angeles*

Mike Kelley **His Master's Voice**
1983, acrylic on paper, 42" x 70".
Courtesy Rosamund Felsen Gallery,
Los Angeles.
*Photograph: Douglas M. Parker Studio,
Los Angeles*

Mike Kelley **Untitled #3**
1994, enamel on aluminum, 62½" x 40". Courtesy Rosamund Felsen Gallery, Los Angeles.
Photograph: Douglas M. Parker Studio, Los Angeles

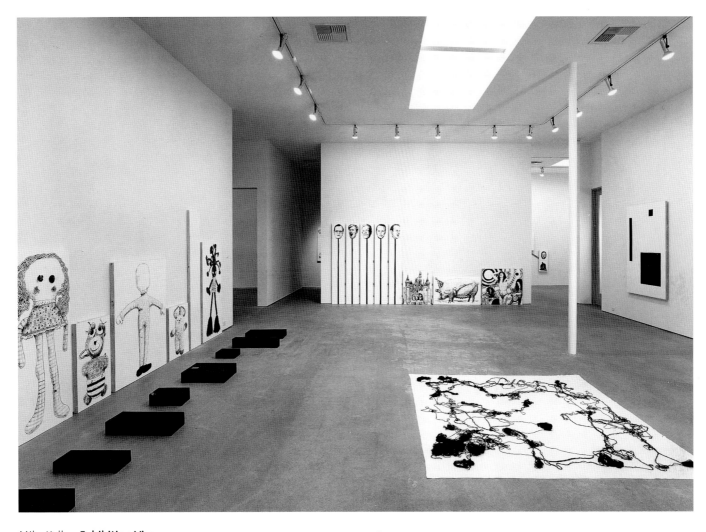

Mike Kelley **Exhibition View**
Rosamund Felsen Gallery, Los Angeles, 6 October – 10 November 1990. Courtesy Rosamund Felsen Gallery, Los Angeles.
Photograph: Douglas M. Parker Studio, Los Angeles

Daniel J. **Martinez**

Martinez terms himself a "cross-media conceptual artist," although *provocateur* may be another appropriate description. Since the late 1980s he has utilized a variety of media and methods of communication or expression including video, photography, street banners, buttons, sculpture, billboards, opera and telecommunications in site-specific installations, performances and public art projects. Ninety-nine per cent of his works are politically oriented, theatrical, and incorporate a wide spectrum of media in an exploration of complex compositions of artistic, historical, political, social, and cultural ideas.

A *provocateur* acts to provoke, and to create debate. As his work has matured, Martinez has tended to emphasize the experiential event above the physical installation. This has mirrored his move from traditional artistic creation to the orchestration common in spectacle art of the last ten years. The difference might be described as the contrast between letting the work itself unfold, and taking a more active role in directing. As he articulates, "My role as an artist is to serve as the catalyst who senses and captures the multi-layers of my socio-physical environment and then, acting the gyroscope, rebalances the various forces that affect the viewer's understanding of reality." "Redirecting" might be substituted for his diagnostic description of "rebalancing."

Since the late 1980s, defining boundaries and space has become a determining factor for much of the provocation in his work. After introduction to a place, Martinez identifies the territorial politics and larger issues of the site at hand. The space that is territorially marked by his work is politicized, and a viewer/participant is placed in the position of self-examination: "Who are you? Where are you? Identify your place. Question, defend or change it."

In 1991 he installed "Nine Ways to Improve the Quality of Your Life," a series of two-sided street banners hung on streetlight poles throughout the affluent shopping area of downtown Seattle, which garnered an enormous amount of local controversy as he queried between the "haves" and "have-nots." "Do You Have a Beach House or a Mountain House? Do You Have a Place to Live?"

Martinez prefers to put a provocative element into the system and see how it can interrupt, change or shift patterns of people's thought — and lives. For the Whitney Biennial in 1993 he made lapel buttons available to everyone entering the museum, with all or parts of the phrase "I Can't Ever Imagine Wanting to be White."

His works tend to involve an enormous amount of community organizing and logistical arrangements. The final artwork can be temporary (in Chicago, 1993, although *Consequences of a Gesture* and *100 Victories, 10,000 Tears* involved a parade and temporary installation, community organizers vowed to make the parade an annual event), but produces far-reaching results. Provocative, subversive, intellectually engaging, and different, it is a new form of art for the late 1990s.

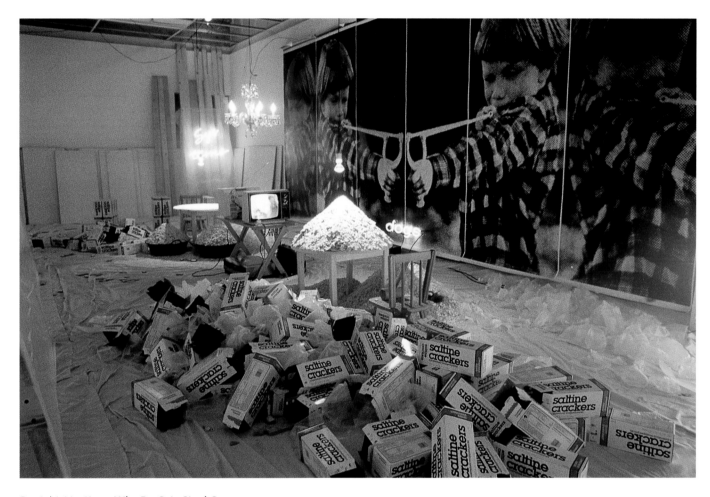

Daniel J. Martinez **Why Do Cats Steal Cream**
1993, installation/video/performance, Mt Saint Mary's College, Art Gallery, Los Angeles, neon, crackers, cut wood sculptures, "Bright White Fear, Off White Guilt, Flat White Stupidity"

Michael C. **McMillen**

Play is a serious feature in McMillen's work, and is used to excavate history, memory and perception. Playfulness is employed to enliven what could otherwise be cold, academic ideas. McMillen twists the viewer's sense of time, using scale and cunning craftsmanship to warp the senses. The patinas and acquired age of a piece's parts are the product of human interaction, and the work allows that interaction to peel off in layers like a very bad sunburn that keeps erupting, and scaling off in ever-widening patches of dead skin, until finally a healthy, living layer emerges.

McMillen's work may appear like playful assemblage. In actuality, an underlying major theme of his work is an ongoing struggle to plumb (understand may be too strong a characterization) the complexity of the urban experience; especially as it exists in the recent (1940s, 1950s) memory of many Americans. Great tomfoolery, creations that owe their existence to the spirit of Rube Goldberg and model making, blend the worlds of eccentric inventor, observing historian, and sentimental poet.

His works are fashioned equally from personal memory and private invention, and make oblique references to reality. Their ingenuity and wit is often expressed in wood, and they seem to be the products of an enternally teenaged dreamer, who may have tinkered with chemistry or erector sets in the 1950s and 1960s. (From the 1930s to the 1960s, erector sets were the equivalent of the present-day Lego building blocks; "chemistry sets" are still available, although both are being quickly supplanted by computers and related "educational toys".)

A worn patina signals the passage of time, and while it may be a signifier for the experience that has created it, the object itself has been relieved of something. McMillen believes in two dictums: that science is still a magical mystery, and that craftsmanship may blur the line between past and present. Through fastidious crafts-manship, McMillen restores magic to the present by making the illusion achievable, believable but imperfect, and philosophically and wondrously multifaceted.

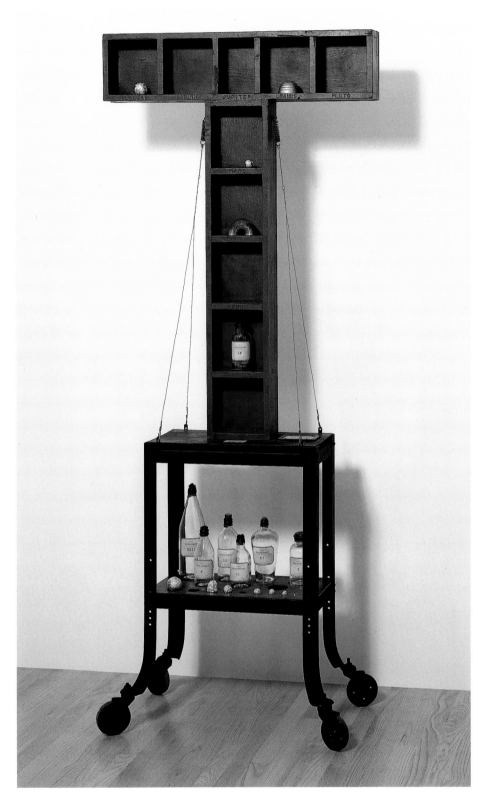

Michael C. McMillen **Another Congress of Matter ...**
1994–95, mixed media, 81½" x 34" x 15". Courtesy L.A. Louver Gallery, Los Angeles

Tim **Miller**

When enough distance is gained to evaluate the emergence of performance art in the 1970s and 1980s, a great deal of it will probably be dismissed for being self-indulgent confessions or bad theater. Work that is more than witty, more than stage entertainment will prominently figure in such an examination, and Tim Miller will be included in that exalted discussion. His work *is* personal, but like all successful art it has qualities that can strike personal chords even in its activism. In *High Performance* in 1993, it was observed that "all his various performance art agitating goes towards articulating a queer cultural identity and trying to find an artistic, spiritual and political response to the AIDS crisis." Miller's peformance works include *Postwar*, 1982, *Cost of Living*, 1983, *Democracy in America*, 1984, *Buddy Systems*, 1985, *Some Golden States*, 1987, *Stretch Marks*, 1989, *Sex/Love/Stories*, 1991, and *My Queer Body*, 1992.

In *Stretch Marks*, Miller segues and digresses from story to story connecting events into a philosophical time line with verbal bridges and stage props. Turning thirty, intimations of mortality rather than only being self-focused, musing on the stories and histories of others his age. A confessed fear of flying, subjectivity turned into dramatic form to animate events, unraveled the experiences and stories of others.

Miller tours nationally and internationally as a solo artist organizing gay communities and conducting residencies in many of the places he performs. He looks like he belongs in a local theater revue, trim, athletic, and slightly boyish. But his work is contained by such stereotypical considerations, and it is to the point and "in your face." His participation in public protests as a member of ACT-UP set new standards for young performance artists, erasing the boundaries between art and life while generally raising levels of professional excellence. He considers his social activism, sex life, organizing, space building, and Sunday family dinners as much a part of his creative work as his performances.

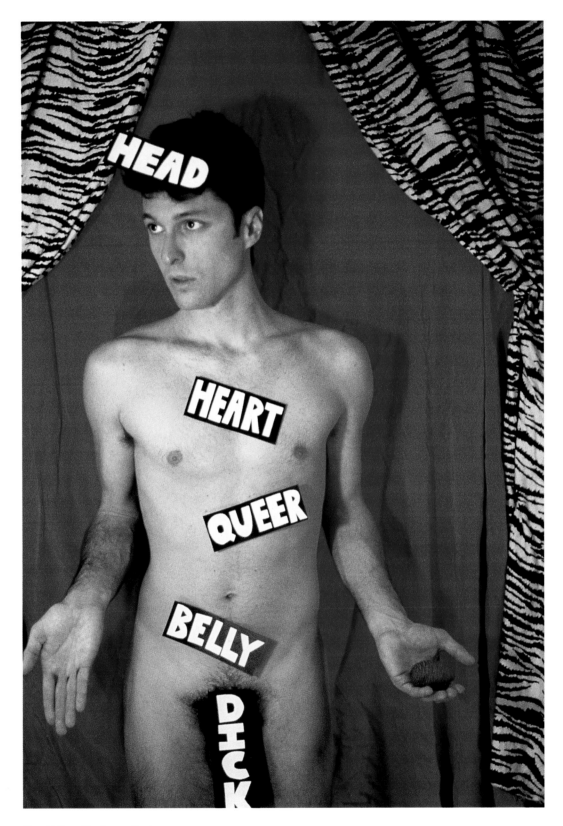

Tim Miller **My Queer Body**
1992, performance

Renée **Petropoulos**

It was probably a combination of her own multicultural background and undergraduate art education that contributed to the special interest of Petropoulos in art and visual representation. The knowledge that things have an identity and meaning beyond their appearance, and also have meanings that transcend time, social, and cultural shifts, is central to an appreciation of her work. Characteristically, her paintings are intellectually clever, beautifully designed and painted, and hold multiple meanings and/or implications based on their referential sources. Little can be accepted at face value in her paintings as everything is carefully selected and put into place; they appear deceptively beautiful, and hold a treasure chest of musings beyond any immediate appearance or effect.

Whether using a country's flag or the colors and patterns commonly found in the apparel of a particular culture, Petropoulos borrows recognizable symbols, colors and forms indigenous to defined nationalities, and uses those specific referential features as carriers of meaning. She makes work so beautiful that it borders on decorative abstraction, and seductively fills it with meaning; regardless of how abstract or beautifully patterned a work might appear, each and every image (representational or symbolic) is presented as part of a world of ideas.

There are pictures within pictures within pictures. She typically works on a series of works, and uses the marks of a society or culture to weave a dialectic presentation, a comparison between things such as the present and some specific point in the past. Maps, funerary wreaths, heraldic devices, cameos, baroque arabesques of ironwork, carved wood, and flowers are some of the images she uses to interrogate issues of framing, identity, national identity, and personal identity.

The importance of language is evident in the titles of different series and individual works. Some examples of the latter are *Show Us Their Faces, Tell Us What They Said*, 1995, *The Chicken Or the Egg*, 1991, and *Set Free to Roam the World: A Study in Similarities and Differences*, 1989; while the latter are no less poetic or potent, and included among them are *All Men Attempt the Thing and Its Opposite; Metropolis after Albrecht Dürer after Leonardo da Vinci, 1507*, 1988, *The Quarter (tails), The Knot — Is It Possible the Whole History of the World Has Been Misunderstood?*, 1988–89, and *A World Wholly Alive Has a Hellish Power*, 1989–90.

Petropoulos has become active in public art projects over the past ten years and these projects build on her interests in language, ideas, and perceptions as they can be mediated by symmetry, site location, scale, and representation.

Renée Petropoulos **Show Us Their Faces, Tell Us What They Said**
1995, oil on wood, 72" diameter. Courtesy Rosamund Felsen Gallery, Los Angeles.
Photograph: Douglas M. Parker Studio, Los Angeles

Renée Petropoulos **Feet on the Ground**
1991, installation, oil on 2 panels, each 30" x 24". Courtesy Rosamund Felsen Gallery, Los Angeles

Renée Petropoulos **All Men Attempt Both the Thing and Its Opposite: Renée Petropoulos After Andrea Mantegna, 1493–1496**
1989, oil on wood, flags, 75" x 46". Courtesy Rosamund Felsen Gallery, Los Angeles.
Photograph: Douglas M. Parker Studio, Los Angeles

Charles **Ray**

Ray's first significant forays into art began with the use of his own body in pieces that occupied a disturbing middle ground between performance and sculpture. *Plank Piece I, II*, 1973, had his body as a sculptural element pinned to the wall by a wood plank. Subsequently, shock, physical consciousness, wonder, conceptual intrigue, and surprise have been features that appear in his work. Like Puck, the cool, distanced trickster, Ray plays with materials and the viewer's expectations. His palette is unpredictable. In the 1970s it was wood and his body, often naked, trussed up, boxed, laid on shelving, and often painted wholly or in part. In the early 1980s it was metal, glass, porcelain, and liquids, often with movement. In the late 1980s plastic forms and photographs were used to create a thing with equilibrium of its own, but nonetheless disturbing. It is as if the plane of reality has been tilted at one end towards what is familiar, while the other side veers away into some other dimension that dislocates simple identity.

Ray moved himself out of his work in the 1970s and early 1980s, and wrestled something more from the legacy left by Minimal sculpture in the late 1960s and early 1970s. *Ink Box*, 1986, *Ink Line*, 1987, and *Rotating Circle*, 1988, best exemplify this period of his work, with their mesmerizing presence and almost invisible latent power. They function to turn Minimal sculpture inside-out. *Ink Box* appears as a cube, yet brimming with 200 gallons of printers' ink that poses danger to any viewer that dares touch or disturb the illusion of a slick solid surface. Likewise, in *Ink Line* a magical black thread runs from ceiling to floor, and in *Rotating Circle* a spinning disk that has been painted the same color as the wall, and set almost imperceptibly flush with its surface, revolves at a speed which makes the motion undetectable, except for the motor's hum and slight air displacement. Minimal, magical, and creating a heightened awareness of the moment, they are also seem to come from a crazed, slightly hallucinatory present.

For Ray, the world is an inexhaustible source of perceptual deceptions, accumulated meanings and forged proportions. *Fall '91*, then, is perfectly suited as an investigation between esthetics and cultural or social meanings. An eight-foot-tall female mannequin, power dressed, towers over all museum visitors. The mythic Amazon, made contemporary, magically exists in Ray's strange relationship between emotion and logic, and between drama and anxiety.

Ray's work sidles up to the edge of spectacular, and then delights in surprising the viewer by not going over the edge, but laterally with its Kafkaesque sideshow qualities. There is a deep kinesthetic feeling in his best works, an anxiety of surfaces combined with a hallucinatory reality.

Ray treats the viewer as a spectator, continually reinforcing the notion that appearances are deceiving. The strange interrelationship among people, social, cultural and the natural forces of the world are what he teases the audience towards, and like the work of Harry Houdini, he seems to both enjoy and be very good at it.

Charles Ray **Fire Truck (outside the Whitney Museum of American Art, New York)**
1993, aluminum, fiberglass, and plexiglass. *Photograph: Ari Mintz © Newsday*

Frank **Romero**

Romero represents the Latino, the outsider shut out of easy access to the art world by virtue of his background and style. His impassioned, at times almost wild, brushwork is not in the tradition of the European refinement that descended from sixteenth-century Holland. Rather, a viewer is confronted with scenes and circumstances that are as ragged and raw as the places where they might happen: East Los Angeles, home base for 100 years to Mexican immigrants, and repository of a culturally rich society. Romero is not a painter of "realism," but re-imagines life, places, people, and circumstances within the unique space-time planes of existence that form the borders of his canvas.

Romero shied away (as any self-respecting, non-white artist might) from the institutional hoops and hurdles and acrobatics which are necessary to achieve a proper recognition, and with it financial independence, in the contemporary art market. In other words, he stepped away from the "approved" paths of becoming an artist, and followed his own muse, without any special mentoring.

The raw liveliness of the gaucho, the zoot suiter, even the contemporary "home boy" breathes in Romero's paintings. There is a history here, but it isn't the George Washington, east-coast, WASP (white Anglo-Saxon Protestant) story. It is what constitutes a major part of the history of Los Angeles. Mexican. Mayan. Mexican-Americans living in Los Angeles longer than most Anglos. The colors and shapes and subject matter belong to this heritage. Bright colors in thickly laid brushstrokes move the action and subjects as if a flat drawing is slowly coming alive and taking form.

Romero's reality of LA is that of a native son Chicano, and it resonates through his images. Symbols of culture, symbols of modern-day LA and personalized symbols from his life are given equal weight in the landscape of his imagination. Swirls of color, a landscape-edge dotted with palm trees, a few twisting curves of freeway are deftly orchestrated into the quintessential LA portrait. He has seen and painted its recent history, a once vibrant downtown that has been lost in the wake of changes over the past thirty years. He has seen its tough side — cops in patrol cars or on horseback warily eyeing the denizens of east LA, hassling the locals because of their heritage. It is a fact.

Romero doesn't paint gingerly, but lustily lays it on. A brusque application of brushstroked color that is the light and guts of an experience of Los Angeles. It is his truth.

Frank Romero **La Cresta**
1990, oil on canvas, 48" x 36"

Nancy **Rubins**

Rubins transforms man-made found objects into larger-than-life art sculptures. Her recycling of industrial trash reflects her minimalist art tendencies, evokes the human associations that are evident in many manufactured things, and identifies the subtle and blatant ironies of mass consumerism. She gives form to a latent trait of American society, and most Western European countries, that of obsolescence and trash. Her piles of raw material, massive mountains appropriately arranged to adequately achieve an "otherness" as art, redefine conventional artistic ideas of size and beauty. She makes big, ugly art.

Discarded appliances, piles of mangy water heaters, and dismembered planes are her palette. (She has collected and wired together hundreds of parts from crashed and outdated aircraft and stored them in the desert, which has become both an archeological site and storage center.) She scavenges on a monumental scale, and aggressively creates a precarious conglomeration of detritus that is almost transformed into architecture by its vast size. She orchestrates these unarticulated masses that are big with potential (and possibly, sheer weight), have a basic junkyard appeal, are monstrous in a Gothic way, and threaten to cascade or collapse at any moment into monumental art. It is an assault on, and artistic recycling of, a disposable society.

The hyperactive efforts which are necessary to accumulate, organize, conceptualize, and install this work are also present in her "drawings." Sheets of paper are completely covered with pencil stick rubbings, and the slick sheen of dark graphite makes the paper appear like thin lead sheets. These sheets are akin to her transient monuments, in that they are the product of her relentless drive to constantly do more, and produce *more*. Her work does not exist without a humorous side. *Mattresses and Cakes*, 1993, involved the remaking of *Self Portrait as a Birthday Cake*, 1973, with the configured arrangement of 150 mattresses and 300 store-bought cakes packed into the crevices. The cake caulked the mattress blocks, and served as the functional "over the edge" element that imbued the work with the contrasting qualities of degenerative luxury, worn cast-offs and seemingly "inappropriately" combined media. The piece was shown in several venues with varying numbers of mattresses and cakes, based on the size of the location.

Her sculpture needs to be site-specific, dictated by the amount of the gargantuan proportions that can be accommodated. They are strong physical assaults that may function as wake-up calls. Their presence forces imprinting on a viewer's mind. Her works harbor an organic feature in that they are not precious, and will naturally grow … and disintegrate.

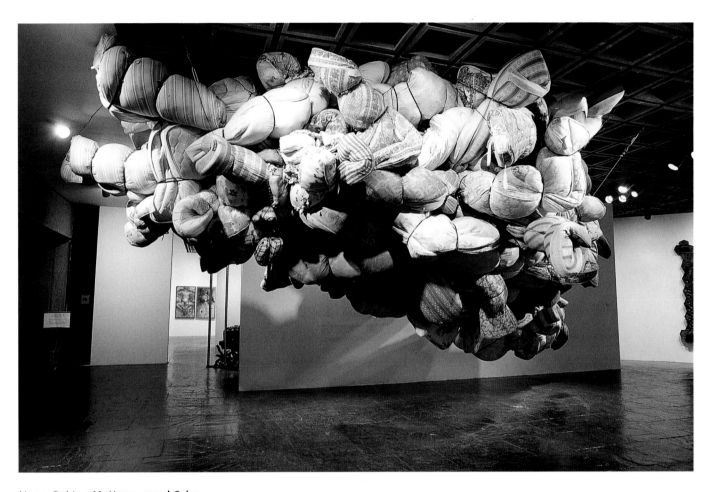

Nancy Rubins **Mattresses and Cakes**
1993, at the 1995 Whitney Biennial Exhibition, Whitney Museum of American Art, New York.
Courtesy Paul Kasmin Gallery and Burnett Miller Gallery, Los Angeles

Ed **Ruscha**

Edward Ruscha drove out of Oklahoma to Los Angeles, attended art school and turned his back on the prevailing last gasps of Abstract Expressionism. He trained in commercial design, embraced the ideals of Pop, and began a career of work that since the late 1960s is immediately identified with Southern California or, more specifically, Los Angeles. It is fitting that a displaced Okie would create art that is so thoroughly *California* in spirit and essence, for Los Angeles, home to Hollywood, is the best possible place where anything goes, and ideas can be formed, borrowed and reconstituted in fresh new ways that make perfect sense.

Ruscha took what Pop art ignored, all the generic language that is used in and around advertising, and made text into paintings. Not just language as words, but letters and their arrangement as a rich visual resource for personal experience and imagination. The language of his early works is booming and bold, and individual words assume an emphasis and dimension that is beyond what they carry in commonplace speech or on the printed page. They become resonant in imaginative sound, like voiced emotions, and are made alive by the perception of a viewer.

Ruscha took what was average, and made it original. He made more than a dozen artists' books in the 1960s and 1970s, adding to the vocabularies of conceptual art, photography, bookmaking, and performance. The words or phrases in his paintings became exclamatory and onomatopoetic, and as sentences appeared they were like proverbs or lines of haiku fully integrated with the painted image. He printed and painted with vegetable dyes, silkscreened with foodstuffs, all the time maintaining a deadpan presentation, graphic simplicity, and thought-provoking wit. Word and image were one, could be reflective, might be romantic or mark a poignant sense of passage. Small phrases were given a poetic lilt and weight: it was the words, it is the painting and it is undeniably the experience of the whole.

Ruscha's use of words has extended our appreciation of painting and language. His works cannot be termed narrative within established use, nor simply poetic. He does use them to their greatest extent, creating absurdity and paradox or subversion, camouflaging much of it in subtle, seductive ways. In the 1980s, Ruscha shifted to dark ominous silhouettes of horses, trees, galleons, and the luminescent lighting disappeared. These wordless silhouettes, blurred, misty images like an out-of-focus 1930s movie trailer, needed no text, for Ruscha had found the subject that was/is image and word: film. The words and sound are in our heads. It is the painting.

Ed Ruscha **Lazy Boy**
1993, acrylic on linen, 21" x 24"

Betye Saar

Saar is, perhaps, one of the most under-recognized, under-appreciated Los Angeles artists of the past forty years. A career that was slowed by family obligation, sporadic educational opportunities and the stark disadvantage of being a black female artist contributed both to her marginal acceptance in the art world, and the richness of her works. In the middle to late 1960s, Saar made a transition from printmaking to sculptural work, and by the late 1970s and early 1980s was working with found objects and fabricated installations.

The influences of institutional training or circumstantial distractions are present throughout many of her early works. Still, she was quick to incorporate timely cultural, political and/or social symbols into works that were not stylistically in vogue at the time of their creation. Saar's work exists as a model of comparison for all other female artists of the 1970s: the consistent, almost dogged, exploration of how symbolic objects/images are drawn from everyday experience. Saar has always evidenced an attraction to the metaphysical, that which is spiritual or intuitive and exists beyond natural or technological (material) worlds. The emotional underlay of her work, allied more with the assemblage work of the 1950s, 1960s, and early 1970s, exists in direct contrast to the male, "automatic," and relatively emotionless assemblage sculpture that was produced in the wake of conceptually based or Minimal art of the late 1960s and early 1970s.

The drive that required her to keep making art, despite circumstances conspiring to deprive her of time and opportunity, is mute testament to her will and strength. Ritual, ceremony, and spirit worship are recurring themes in her work of the past twenty years, as familiar objects are linked with supernatural worlds. Her academic training, and sensitivity to culture and history, made the transition to community responsive public work a natural shift. *House of the Open Hand*, 1989, an assemblage and mural at Broadway-Spring Center in downtown Los Angeles, was created as part of a public art commission to The Power of Place group of artists, for celebration, documentation, and honor of Biddy Mason, an early black pioneer of Los Angeles. Saar's symbolic use of objects, and specific use of information (photographs), adds a familiarizing "homey" quality to what can otherwise be cold, hard information (figuratively and literally when concrete or steel are involved).

While Saar's work does not assume the biting, even sarcastic, stance of many younger artists, it does have a timely social and cultural resonance. Drawing together folk traditions, ritual, myth, spirituality, and history, her work has consistently pushed "accepted" artistic boundaries. Additionally, her public art commissions are important precedents for socially connected and conscious work, especially in the turbulent, confusing maelstrom that has constituted artistic life in Los Angeles since 1980.

Betye Saar **The Ritual Journey**
1992, installation, Joseloff Gallery, University of Hartford, Connecticut, 10' x 15' x 45' x 20'. *Photograph: Bob Calafiore*

Adrian Saxe

The works of Saxe immediately made sense during my first trip to Spain, for unlike the cultures of Italy or France the Spanish culture is an amalgam of many different cultures over the past two thousand years. Greek settlements, Roman occupation, Moorish rule and finally Christian seats of power have all gone into forming architecture, utilitarian vessels and even cuisine, whose roots owe allegiance to these many influences.

In his works, Saxe has fused complex historical references to societies, popular culture, the genealogy of ceramics, and high art. He exploits the properties of ceramics for presentation and display in a scale that always retains an elegance and balance, even in its incorporation of color and conceptual play. The works engage a viewer with their anthropomorphic, witty appearance to yield deeper considerations of history, social, and cultural perspectives.

It is a marriage of exquisite craft and deep perception, without any historical precedent. His fragmentation of a pot's parts, pushing them into themes of history, taste, esthetics, and style, some being organic in nature and others architectural, joins styles and materials in a manner that isolates the different components of a vessel, yet retains a muscular individuality.

In the early 1980s, Saxe developed the dialectical style that has since characterized his works. Mixing functions, styles, cultures, shapes, materials, and surfaces, he has experimented with the Asian styles that were most popular among American ceramicists in the 1960s, but saved most of his work for an exploration of what was European. In his works, social and cultural territory are not monolithic entities, but paths through which certain cultural and social values are developed and acquired. A piece by Saxe invites queries: "What is the historical reference of the quotation being used?" "Describe the formal properties: vessel, base, their relationship, and not discrepancies among materials, the shape and function of the work." "What 'transnational' symbols or materials are drawn from different periods and other styles of sculpture?" "Are inappropriate combinations at odds with their intrinsic value (as beauty, as collectibles)?"

These are the true struggles between the craftsman potter and the artist, the general public and the private art worlds. Saxe is renowned for his combinations of emblematic forms, unusual handles, touches of whimsy, and richly colored glazes. He has appropriated, re-articulated and refined the craft far more closely to the ways in which it was conceived; it is an artform when produced from his mind and hands, and invention or creation rises to the head of the list of descriptions that are used to gain an understanding of the artistic expression that makes his work "worthy" of time and investment.

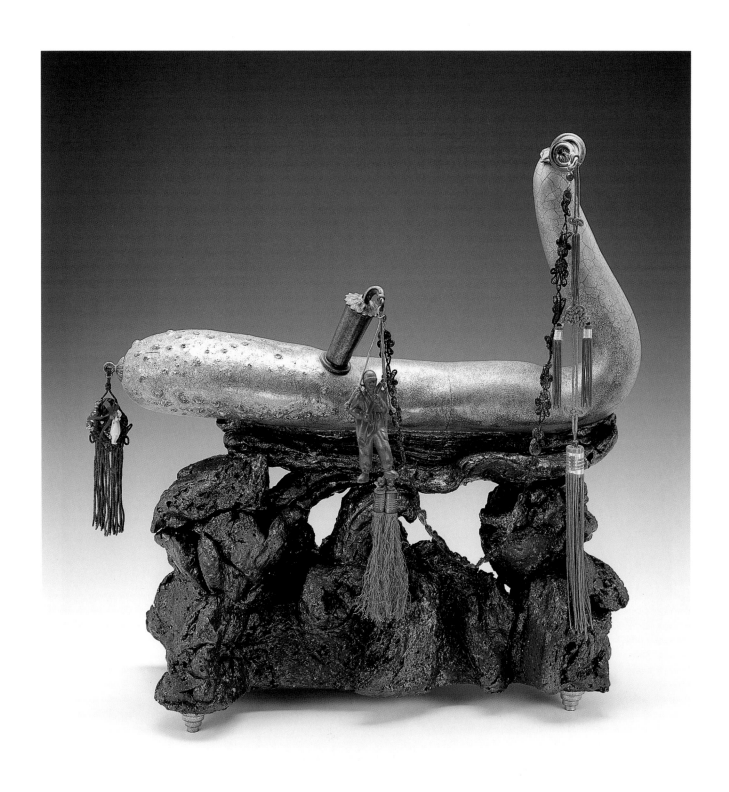

Adrian Saxe **Ankyloglosia**
1993, porcelain, stoneware, and mixed media, 23" x 22½". *Photograph: A. Cuñha*

Ilene **Segalove**

If "Fernwood Tonight," a now defunct television series that parodied the late night interview talk shows, had a correspondent-at-large, that person would have been Ilene Segalove. Her work is the product of a special mind, historically and culturally incisive, visually dramatic, and witty. Visual, sound and media artist, she brings "funny" into galleries and museums, a level of amusement that is more than William Wegman's cute Weimaraner dogs, such as bemused observations on her life and how we live our lives.

Segalove manages to puncture a lot of subject matter in her work. Whatever is the primary subject, many more issues are pulled into play. Much of her work is based on growing up, and these quasi-autobiographical narratives are both personal and universal. Often her playground is between reality and appearance, what is implied or may be explicit, and the consequences that either path may produce.

A striking quality about Segalove's work is that it is "well-mannered." This is not to say that it is tame, or boring, or mundane, rather that what she uses and capitalizes on is not based on being shocking or offensive. While this knowledge is useful, it doesn't mean that you (your beliefs) will go unskewered. But even if nailed by her insights or observations, you'll probably laugh or, at least, chuckle. Segalove has delved into the social effects of television in a comic fashion, produced radio and made still photographic pieces that tweak the collective ego. If she skewers history, art and social values also get their due along the way. (The terms "history," "art" and "social values" are entirely interchangeable in the previous sentence.) Her observation and recounting of the most banal moments or observations in life are translated into amusing, meaningful stories.

Her videos are visually sophisticated and psychologically intricate, as she has used childhood experiences, relationships among child, mother, father, and reflections on growing up for spreading out topics of feminism, science, art, and cultural history.

Add to this her radio work, mixed-media still pieces, and one finds no clear answer to the mishmash jumble that constitutes the almost fifty years of media that she has been plumbing for meaning. At least, not yet. The key will be when all the parts begin to coalesce at some point in an indeterminable future, and her stories are no longer simply short vignettes, but full-length, gasping, exhilarating tales of emotion, angst, and life. Even if they are made up.

Ilene Segalove **Thank You, ILLUSION**
1993, silver, oil, 27" x 42"

Peter **Shire**

One of the original artists of Memphis, the Italian-based design group that became well known in the early 1980s, Shire has made fanciful teapots, built furniture and (jaunty) sculptural objects that balance form and function. Italian Ettore Sottsass, the organizing force behind the Memphis group, sought adventurous, high-quality design that would be functional and affordable.

Shire was perfect for this role, as his carnival-like teapots and furniture were easily (conceptually) expanded into the conceptual framework of the group esthetic. Wild shapes, colors, and a playful sense of irreverence towards the way "things should be" had characterized most of his design- and craft-oriented efforts to this point. His experience with Memphis forced him to creatively deal with the often conflicting areas of craft and art, and his work grew as a consequence. "Ceramic Freeways: A Ten Year Teapot Retrospective" at the Municipal Art Gallery, Los Angeles, in 1985, displayed hundreds of teapots that he made during the years from 1974 to 1984, and in 1985 he sold his wheel and kiln to concentrate on the design of furniture and sculpture.

Artists who cross over between design and art, or craft and art, often encounter a great deal of resistance in being seriously accepted by purists in the art world. Shire has managed to retain an adventurous edge in his work, and definitely does not sit back or indulge the status quo. For over fifteen years prior to the "Ceramic Freeways" exhibition Shire made ceramic portraits of family, friends, and neighbors. When included in the show (they were not for sale since they were not made as commercial objects) they revealed his interconnectedness with the cultural diversity that characterizes Los Angeles.

Shire moved to working with large-scale public sculptures in the past fifteen years, and the lessons he learned seem most understandable in terms of taking his knowledge of furniture design far beyond the needs of human comfort. These works still operate on a human scale, especially when experienced up close, but also hold gargantuan levels of scale and space that make the work seem almost toy-like at a distance. His teapots were distinct and individual enough to have a presence, and effect, on their surroundings. Shire is now able to affect (or effect) much larger environments through his large-scale work. A few other characteristics that are commonly found throughout his work are an exuberant use of wild shapes and colors, and a playfulness that enforces their need for human interaction. User-friendly art.

Peter Shire **Youns Table**
1986, steel, anodized aluminum, chrome, and enamel, 29" x 60" x 48". *Photograph: William Nettles*

Alexis **Smith**

The differentiation between collage and assemblage is that collage is usually flat, may include contemporary material and will likely be directed to express or communicate a specific theme, while assemblage is frequently multi-dimensional, utlilizes parts that have acquired a patina (time past) and are somewhat general in what they convey as an idea. Smith has built her collage work on an exploration of American myth, embracing the "low art" of popular culture, such as movies, romance novels, magazines, and advertising, and moved it onto the "high ground" of fine art, frequently with humor and a light touch. In her hands, collage is used to its best advantage as a unity of the different voices from found images, objects, and texts, which are shaped to force their familiar effects on us with new meanings.

Combining visual and written information, the work cheerfully engages the urban world and probes the mental health of both the culture and human experience. The romance of what is American, both specifically and generally, and how those stories define or contextualize individuals, is a theme that runs through much of the work. In Los Angeles, the guiding lights, heavenly bodies and stars of the landscape twinkle in Hollywood. It is a world of enchantment, and Smith is both historian of its heart and archeologist of its mind.

Her works are often "mini-stories," as what may be metaphoric is determined and extended by the interrelationships which develop between word and image. After all, Hollywood was the garish culture in an otherwise bleak western landscape, and Smith plays it for all it is worth with witty commentary and incisive double entendres. It is memory that is alive here, something palpable as opposed to the worn patina of nostalgia. In some of her strongest pieces, the found is indistinguishable from what is made, and the piece and frame are artfully blended to be part of the object.

The importance of words chronologically diminishes through her work as the image and infrastructure of the physical experience has grown and become more encompassing. Her knowledge and developed abilities in presentation and display have been admirably carried over into her public art installations. Most notable among these are *The Grand*, 1983, an 8,000-square-foot permanent painted installation on three levels with collage works in Grand Rapids, Michigan; *Snake Path*, 1992, a 560-foot-long, 10-feet-wide work with a 7-foot-high granite book on the University of California, San Diego campus; and the terrazo floor designs (1993) for the west and south lobbies of the Los Angeles Convention Center which include a map of the Pacific Rim and chart of the night sky.

Alexis Smith **Marriage on the Rocks**
1995, mixed-media collage, 31" x 43½". Courtesy Margo Leavin Gallery, Los Angeles. *Photograph: Douglas M. Parker Studio, Los Angeles*

Robert **Therrien**

There is an anonymity about Therrien's work, as if any sense of authorship is being held at arm's length. His pieces force a dislocation of an observer's viewpoint as the familiarity of form is used and exploited to dramatize what could be otherwise unnoticed. The effect is engineered through forcing an observer to look and observe in a particular way, whereby physical relationships take on a power and presence that is more than what an image could convey, and with this revelation produce a meditation and exploration of space, physicality, surface, and scale.

His paintings, sculpture, drawings, and installations all retain a physical relationship to their surroundings. The context of color, materials, form, tone, and shape become tools for the discovery of something new in our surroundings. Forms are coopted for the feeling and idea in their original source. It may be an architectural detail, animal form or geometric shape with resonant proportions. It is a reduction of shapes to *feeling*, a reinvention as something referential, not representational. Not surprisingly, each installation is individual, his pieces intrinsically related to the walls, floor, ceiling, and surfaces of the room.

His works in the early 1980s were almost systematically separated on the basis of what they explored. There were larger, individual sculptures. A group of shallow reliefs on a rectangular surface, described as plaques by him, explored the interrelationship of object to surface plane and edge(s). Works with steeple-like shapes, or based on keyhole and keystone shapes, would have many layers of paint applied, and likely be rubbed or scratched to achieve both the color and surface he desired. Therrien has worked with a wide variety of materials including brass, bronze, copper, oil, paint, plaster, resin, and different kinds of woods. This experience has provided him with a wide and varied palette to produce things that *feel just right*.

Therrien's movement between painting, sculpture, and installation suggests a restless mind at work. While his paintings and simple sculptural forms of the early 1980s isolated individual, almost iconic, features, works in the past ten years have assumed more complex elements and proportions. Information that might have been previously marginalized by its reduction or elimination, has been dramatically increased through pieces that seem more orchestral as propositions. In addition, Therrien has taken on a vocabulary that is more common, yet no less potent, in how it is wielded in the queries he desires to present.

Robert Therrien **No Title**
1990, metal and mixed media, 46" x 36" x 13". Collection: The Carnegie Museum of Art, Pittsburg, Philadelphia.
Photograph: Douglas M. Parker Studio, Los Angeles

Bill **Viola**

An unmatched pioneer in the elevation of video to an artform, Viola has consistently expanded and refined his work in twenty-five years. Since 1972 he has produced more than seventy tapes and installations, ranging from wordless observations of objects and events constructed to reveal the underlying psychic structures of visual experience, to rich productions that employ music and theatrical orchestrations of time and space. Viola has moved video beyond a one-way narration on a monitor to its full potential as a vehicle of sound and time that can profoundly affect a viewer's conscious and unconscious mind.

Pace has played an important structural role in the construction of his pieces. There is deliberate, conscious slowing of action, one of many tools employed by him to counteract the ingrained television/media viewing habits of the general population. This manipulation of pacing also functions to set up a dichotomy between reality and dreamtime in his work.

It is this architecture in his pieces, including superimposition and a mixing of images, which viscerally affect philosophical contact with a viewer. And, when parts are separated in installation, they are given their own space, time and consequently establish their own reality. A theme that can be found throughout many of his works is the achievement or existence of an inner peace, a psychic equilibrium to be used as defense or protection in a belligerent exterior world.

A viewer is made aware (sensitized, "trained") to the importance of time, sound, space, and curiosity, the latter being achieved through a presentation of elusive encounters. Subsequently one is transported beyond the ordinary, even if the action and/or image is within one's range of understanding. Contemplative environments are used for explorations of reality and dreamtime, and what is commonplace becomes a doorway to a higher reality (perception).

In *Theater of Memory*, 1985, a large leafless tree leans diagonally across the room. Fifty small lanterns are hung on its bare branches, a large video image is projected on the rear wall, and static or undecipherable noise fills the room with bursts of sound. The video image visually crackles with recognizable imagery that never quite manages to come through clearly. The very clear physical metaphor of the neurons and neural pathways that constitute the human brain, functions both to "show" us how we may think, and provides an experience (darkened room or "cave") where such clear purpose can refresh and redirect our minds.

Bill Viola **Slowly Turning Narrative**
1992, video/sound installation, commissioned by Institute of Contemporary Art, Philadelphia, Pennsylvania, and Virginia Museum of Fine Art, Richmond, Virginia. Collection: Edition 1, Museo Nacional Centro de Arte Reina Sofia, Madrid, Spain.
Photograph: Gary McKinnis

Peter Zakosky **Skeleton in Landscape**
1995, oil on canvas, 16" x 20"

Peter Zakosky **Two Saints**
1992, oil on canvas, 39¾" x 37½"

15–24 July 1996, p. 52.
Van de Walle, Mark, "Uta Barth at Tanya Bonakdar," *Artforum*, September 1996, p. 109.
Wallenstein, Sven-Olve, *Painting — The Extended Field*, Rooseum — Center for Contemporary Art and Magasin 3 Stockholm Konsthall, Stockhall, Sweden, 1996.

CHRIS BURDEN

Chris Burden's (b. 1946, Boston) parents had intellectual interests with broader world implications. His mother worked as an art restorer at the Fogg Art Museum, and his father was an engineer who lectured at Harvard, advising developing nations on agricultural and energy technologies. From the age of ten, when his parents split up, Burden traveled and lived in boarding schools in Europe. He returned to Boston for high school and in 1965 came to Southern California to attend Pomona College, where he initially studied architecture and received a BFA (1969), studying with Minimalist sculptor Mowry Baden. His graduate work was at the University of California, Irvine (MFA, 1971). Since 1978, he has taught at the University of California, Los Angeles, where he is currently the Head of New Genre. He lives in Topanga Canyon with his wife, artist Nancy Rubins.

Burden's earliest works were performance pieces; between 1971 and 1983, he did more than seventy of these. During this period, he also made more than a dozen videotapes, films, and audiotapes. Burden gained early notoriety in the performance art world for being locked up, shot, crucified, burned, punctured, almost electrocuted and drowned, and run over by a car. Since 1974, he has had more than fifty solo exhibitions of his work in the United States and Europe, including "Three Ghost Ships," 1996, at the Gagosian Gallery, Los Angeles; "Chris Burden: Beyond the Limits," 1996, a retrospective at the Austrian Museum of Applied Arts; "Medusa's Head," 1993, at the Gagosian Gallery, New York; and the retrospective "Chris Burden: A Twenty Year Survey," 1988, at the Newport Harbor Art Museum, Newport Beach, California. His work has been included in over 140 group exhibitions in the United States and Europe since 1971. Notable among these are the Biennial exhibitions at the Whitney Museum of American Art, New York (1977, 1989, 1993, 1997); "Helter Skelter: LA Art of the 1990s," 1992, at the Museum of Contemporary Art, Los Angeles; "Dislocations," 1991, at the Museum of Modern Art, New York; and "Content: A Contemporary Focus, 1974–1984," 1984, at the Hirshhorn Museum and Sculpture Garden, Washington DC.

His awards include grants from the Flintridge Foundation (1998), the National Endowment for the Arts (1974, 1976, 1980, 1983) and a John Simon Guggenheim Foundation Fellowship (1978).

Selected Bibliography
Ayres, Anne, and Schimmel, Paul, *Chris Burden: A Twenty Year Survey*, Newport Harbor Art Museum, Newport Beach, California, 1988.
Chris Burden, The Artist and His Models, Lowe Art Museum, Miami, Florida, 1986.
Noever, Peter (ed.), *Chris Burden: Beyond the Limits*, MAK Österreichisches Museum für angewandte Kunst Vienna; Cantz, Ostfildern, 1996.
Schimmel, Paul, *Helter Skelter: LA Art in the 1990s*, Museum of Contemporary Art, Los Angeles, 1992.
Site Strategies: Terry Allen, Chris Burden, Terry Fox, Oakland Museum, Oakland, California, 1983.
Storr, Robert (ed.), *Dislocations*, Museum of Modern Art, New York; Harry N. Abrams, New York, 1991.

CARL CHENG

Carl Cheng (b. 1942, San Francisco) located with his family to Los Angeles during the Second World War. From 1958 to 1959 he studied at Chouinard Art School, and then pursued fine art and industrial design at UCLA. While a student he worked part time as an illustrator/draftsman for the Division of Research in the Graduate School of Business, and as a photographer for Ethnic Collections. Cheng completed his under-graduate studies (BA, Industrial Arts, 1964) and pursued graduate studies at the Folkwang School of Art in Essen-Werden, Germany, where he studied with Jorg Glasenapp and worked for him as a model builder.

He returned to UCLA in 1966 (MA, 1967), and was among the first photography graduate students of Robert Heinecken. He began to work in photographic sculpture and conceptual artmaking based on photographic phenomena, and established the John Doe Company in 1967. From 1970 to 1972 he traveled to Osaka, Japan, through Southeast Asia, Bali, Indonesia, India, and eventually back to Tokyo. After returning to Los Angeles he began attending lectures and retreats conducted by Tibetan lamas, Hindu yogis, and Buddhist monks, and learned the art of meditation.

After building an in-studio greenhouse in 1973, Cheng began to experiment with growing wheat stalks and cactus implants. He also explored processes of erosion, weathering and decay. During this time he worked as a model builder and prototype fabricator for John Neuhart and as a designer at the Charles Eames Office.

Since 1966 Cheng's work has been included in over sixteen solo exhibitions including "Carl Cheng, John Doe Co. — A Twenty Year Survey," 1991, organized by the Contemporary Art Forum, Santa Barbara, and twenty group exhibitions including "Photography Into Sculpture," 1970, at the Museum of Modern Art, New York, and "Vision and Expression," 1969, at the International Museum of Photography at the George Eastman House, Rochester, New York.

Cheng has received many major public and private commissions including the Marine Station of the Los Angeles County Metropolitan Transportation Authority (opened 1995) and Seattle Underwater, commissioned by the Seattle Arts Commission and Water Department (1982). He has also received two National Endowment for the Arts Visual Arts Fellowships (1982, 1986), and an Individual Artist Grant from the City of Los Angeles (1996).

Selected Bibliography
Cheng, Carl, *John Doe Co.*, Santa Barbara Contemporary Arts Forum, Santa Barbara, California, 1991.
Clothier, Peter, "Carl Cheng/John Doe Co. — 25 year Survey," *ARTnews*, November 1991, p. 156.
Novakov, Anna, "66% Water," *Sculpture Magazine*, March/April 1990.
Willette, J.S.M., "Rite of privacy — the public art of Carl Cheng," *Visions*, Fall 1993, pp. 44–6.

ROBBIE CONAL

Robbie Conal's (b. 1944, New York City) parents were union organizers. He grew up a rabid Brooklyn Dodgers fan and, as an adolescent, haunted the Museum of Modern Art with his friends. Despite his education (BFA, San Francisco State University, 1968; MFA, Stanford University, 1978), Conal is best known as a guerrilla artist.

Since 1988, Conal's work has been the focus of over fifteen solo exhibitions, including "Pet Peeves," 1994, at the Koplin Gallery, Santa Monica, California; "The Art of Attack," 1994, at the Armand Hammer Museum of Art, Los Angeles; "Gag Me With the Supreme Court — Paintings," 1992, at Jayne H. Baum Gallery, New York; and "Unauthorized History: Robbie Conal's Portraits of Power," 1990, at the Armory Center for the Arts, Pasadena, California. Conal's work has been included in more than thirty group exhibitions since 1979, among these "Empowering the Viewer: Art, Politics, and Community," 1992, organized by the William Benton Museum of Art at the University of Connecticut, Storrs, and traveling

to Tyler School of Art, Elkins Park, Pennsylvania; and "Robbie Conal, Jenny Holzer, and Barbara Kruger," 1988, at the Reed College Art Gallery, Portland, Oregon.

Conal is best known for over a dozen different poster projects executed since 17 October 1986, and glued on the buildings, telephone switching boxes, walls around construction sites, and telephone poles of cities including Los Angeles, San Francisco, Chicago, New York City, New Orleans, and Houston. Conal has collaborated on five others and has been commissioned for two billboard projects in Los Angeles (1991, 1992). His work can be viewed in the Art Attack Cafe at www.robbieconal.com.

Selected Bibliography

Conal, Robbie, *Art Attack: The Midnight Politics of a Guerilla Artist*, HarperCollins, New York, 1992.

Irmas, Deborah, *Unauthorized History: Robbie Conal's Portraits of Power*, with an interview by Ralph Rugoff, Pasadena Art Alliance, 1990.

Lazzari, Margaret, "Visual political statements," *Artweek*, vol. 19, 8 October 1988.

Peeps, Claire, "Robbie Conal: taking back the streets," *High Performance*, vol. 38, July/August 1987.

Pincus, Robert L., "Newt is new subject for poster boy of satire," *San Diego Tribune*, 6 February 1995.

EILEEN COWIN

Eileen Cowin (b. 1947, Brooklyn, New York) studied at the State University of New York, New Paltz (BS, 1968), and pursued graduate work with Aaron Siskind and Arthur Siegal at the Illinois Institute of Technology in Chicago (MS, 1970). After several months of work as a substitute teacher and then a photo researcher, she taught at Franconia College in New Hampshire for four years, and since 1975 has taught at California State University in Fullerton where she is a Professor of Art.

Cowin's training in drawing is highly evident in her work until the late 1970s. She worked extensively in various photographic printing techniques including gum bichromate, Kwik-prints, and positive transparencies. In about 1980 Cowin began making color photographs of staged scenes, and since then has also worked extensively in black-and-white, video and computer digitized imagery. Since her first solo show at the Witkin Gallery, New York (1971), her work has been presented in more than thirty solo exhibitions in the United States, Europe, and Japan. Among these are a collaboration with Louise Erdrich at domestic settings, Los Angeles, at the Museum of Contemporary Photography, Columbia College,

Chicago, IL (1991), and the Los Angeles County Museum of Art (1985). Her work has also been included in more than 165 group exhibitions since 1968 including "P.L.A.N." (Photography Los Angeles Now) at the Los Angeles County Museum of Art, 1995; "Proof: Los Angeles Art and the Photograph 1960–1980," 1992 (traveling), at the Laguna Beach Museum of Art; and "Pleasures and Terrors of Domestic Comfort," 1991, at the Museum of Modern Art, New York.

Cowin has received numerous awards, among them are Individual Fellowships from the National Endowment for the Arts (1979, 1982, 1990), an Artist Fellowship from Art Matters, Inc. (1994), and an Individual Artist Grant from the City of Los Angeles (1997).

Selected Bibliography

Gauss, Kathleen, *New American Photography*, Los Angeles County Museum of Art, Los Angeles, 1985.

Hoy, Anne, *Fabrications: Stage, Altered and Appropriated Photographs*, Abbeville Press, New York, 1987.

Kozloff, Max, *The Privileged Eye*, University of New Mexico Press, Albuquerque, New Mexico, 1987.

Rosenbloom, Naomi, *A History of Women in Photography*, Abbeville, New York, 1994.

Smith, Joshua, *The Photography of Invention: American Pictures of the 1980s*, National Museum of American Art, Washington DC, 1989.

JOHN DIVOLA

John Divola (b. 1949, Los Angeles) has lived his entire life in Los Angeles (BA, 1971, California State University, Northridge; MA, 1973; MFA, 1974, University of California, Los Angeles). Since 1975, he has taught art and photography at numerous educational institutions including California Institute of the Arts, and since 1988 he has been Professor of Art at University of California, Riverside.

Since 1975, Divola's work has been featured in more than forty solo exhibitions in the United States, Japan, Europe, and Australia, including the Galerie Niki Diana Marquardt, Paris, 1990; Seibu Gallery, Tokyo 1987; the University of New Mexico Art Museum, 1982; and the Robert Freidus Gallery, New York, 1980. Since 1973, his work has been included in over 130 group exhibitions in the United States, Europe, and Japan, including "Proof: Los Angeles Art and Photography, 1960–1980," 1992, organized by the Laguna Art Museum and traveling to four other venues; "Between Home and Heaven: Contemporary American Landscape Photography," 1992, organized by the National Museum of American Art,

Smithsonian Institution, Washington DC and traveling to five other museums; "California Photography: Remaking Make Believe," 1989, organized by the Museum of Modern Art, New York and traveling to four other venues; and "Photography and Art: Interactions Since 1946," 1987, organized by the Los Angeles County Museum of Art and traveling to three other venues.

Divola is a collector of vintage set stills from Hollywood movies. These images, selected on a thematic basis, have been exhibited on several occasions such as "Hallways, Broken Chairs and Evidence of Aggression," 1996, Patricia Faure Gallery, Santa Monica, and "Neotoma," 1995. A collection of this work was published by SMART Art Press in 1997, under the title *Continuity*.

Among Divola's awards are Individual Artist Fellowships from the National Endowment of the Arts (1973, 1976, 1979, 1990), a John Simon Guggenheim Memorial Fellowship (1986), and a Flintridge Foundation Visual Arts Award (1998).

Selected Bibliography

Foresta, Merry, *Between Home and Heaven, Contemporary Landscape Photography*, National Museum of American Art, University of New Mexico Press, Albuquerque, New Mexico, 1992.

Grundberg, Andy and Gauss, Kathleen, *Photography and Art: Interactions Since 1946*, Los Angeles County Museum of Art, Los Angeles, 1987.

Hagen, Charles, "Art in review," *New York Times*, 20 November 1992.

Mahoney, Robert, "John Divola at Jayne Baum Gallery," *Arts Magazine*, January 1991.

Szarkowski, John, *Mirrors and Windows*, Museum of Modern Art, New York, 1978.

FRED FEHLAU

Fred Fehlau (b. 1958, Long Beach) is a native Californian. Fehlau received a BFA (1978) and MFA (1988) from the Art Center College of Design in Pasadena, California. He has taught at both the Art Center and the Otis College of Art and Design in Los Angeles.

Since 1980, Fehlau's work has been the focus of twelve solo exhibitions, including a series of shows from 1988 to 1995 at the Burnett Miller Gallery, Los Angeles; the Nordenstad-Skarstedt Gallery, New York, 1992; Tony Shafrazi Gallery, New York, 1991; "Margins 1," 1990, at the University of California, Santa Barbara; and "New California Artist Series — #16," 1989, at the Newport Harbor Art Museum, Newport Beach, California. Since 1979, his work has been included in more than forty group exhibitions,

including the 44th Biennial Exhibition of Contemporary American Painting, 1995; "Painting Outside Painting" at the Corcoran Museum of Art, Washington DC; "Enclosure," 1995, at the Museum of Contemporary Art, Los Angeles; "Current Abstractions," 1994, at Municipal Art Gallery, Los Angeles; and "nonrePRESENTation," 1990, at the Gallery at the Plaza, Security Pacific Corporation, Los Angeles.

Fehlau has also worked as an essayist, graphic designer, and was curator of "Hollywood, Hollywood: Identity under the Guise of Celebrity," 1983, Art Center College of Design, Pasadena.

Selected Bibliography
Brougher, Nora Halpern, review, *Flash Art*, vol. 24, no. 157, March/April 1991, p. 143.
Colpitt, Frances, "Fred Fehlau at Newport Harbor Art Museum," *Art in America*, vol. 77, no. 11, November 1989, pp. 203–4.
Nickas, Robert, "Punishment and decoration: art in the age of militant superficiality," *Artforum*, April 1993, pp. 79–83.
Selwyn, Marc, "Fred Fehlau," *Flash Art*, no. 144, January/February 1989, pp. 126–7.
Winer, Andrew, "Fred Fehlau at Burnett Miller," *Art Issues*, no. 16, February/March 1991, p. 34.

JUD FINE

Jud Fine (b. 1944, Los Angeles) is a native Californian. After majoring in history at the University of California at Santa Barbara (BA, 1966), he studied art at Cornell University in New York (MFA, 1970). He began teaching in 1970 at Los Angeles Harbor College, was sculptor-in-residence at the School of the Art Institute of Chicago in 1976 and in 1977 began teaching in the art department at the University of Southern California, where he is now a full Professor.

Since 1972, he has had more than thirty solo exhibitions in the United States and Europe: these include a series of shows at Ronald Feldman Fine Arts in New York beginning in 1972; the Los Angeles Institute of Contemporary Art, 1978; the Los Angeles Municipal Art Gallery at Barnsdall Park, 1985; and a retrospective at the La Jolla Museum of Contemporary Art, 1988. His work has been included in over eighty group shows since 1971. Notable among these are "Documenta 5," 1972, Kassel, Germany; "8th Biennale de Paris," 1973, in France; "71st American Exhibition," 1974, at the Art Institute of Chicago; "View of a Decade," 1977, at the Museum of Contemporary Art, Chicago; and "100 Years of California Sculpture," 1982, at the Oakland Museum, Oakland, California.

Fine has increasingly worked on a number of commissions for architectural projects and public works since 1980, the majority of them in Southern California. Completed projects include *Why Se Pac Art* (1989) for the Security Pacific Art Gallery, Costa Mesa; *Evolation* (1990) for the Carnation Company headquarters in Glendale; and *Spine* (1993) for the Maguire Gardens of the Los Angeles Central Public Library. He has also published a number of artists' books, most recently collaborating in 1993 with Harry Reese on *Spine* for the Los Angeles Library Association.

Among his many awards and honors are an Art in Public Places Grant (1978) and an Individual Fellowship Grant (1982) from the National Endowment for the Arts.

Selected Bibliography
Armstrong, Richard, *Sculpture in California 1975–1980*, San Diego Museum of Art, San Diego, 1980.
Frankel, Dextra, *Jud Fine: Confessions and Related Works 1970–76*, California State University at Fullerton, Art Gallery, 1976.
Onorato, Ronald J., and Grynsztein, Madeleine, *Jud Fine*, La Jolla Museum of Contemporary Art, La Jolla, California, 1988.
Pincus, Robert L., *Jud Fine, February 1985*, essay, and interview with Frances Colpitt and Michael H. Smith, Los Angeles Municipal Art Gallery, Los Angeles, 1985.

JUDY FISKIN

Judy Fiskin (b. 1945, Chicago, Illinois) moved with her family to Los Angeles in 1946, where she attended public schools. She studied art history at Pomona College (BA, 1966), did graduate work in art history at the University of California, Berkeley from 1966 to 1967 and then at the University of California, Los Angeles (MA, 1969). From 1969 to 1970, she compiled and edited the journals of the noted architect Richard Neutra. At one point in the early 1970s, she worked as a designer of rides for a never-built amusement park. Since 1977, Fiskin has been a member of the photography faculty at the California Institute for the Arts in Valencia.

Since 1975, Fiskin's photographs have been featured in twenty-two solo exhibitions, including "Some Art and Some Furniture," 1992, at the Center for Creative Photography, Tucson, Arizona, and the Birmingham Museum, Birmingham, Alabama; a retrospective "Judy Fiskin: Some Photographs, 1973–1992," 1992, at the Museum of Contemporary Art, Los Angeles; "More Art," 1994, at the Patricia Faure Gallery, Santa Monica, California; and "New Photographs," 1994, at Curt Marcus Gallery, New York. Since 1972, her work has been included in more than eighty group

exhibitions, including "After Art: Rethinking 150 Years of Photography," 1995, at the Friends of Photography Ansel Adams Center, San Francisco and other venues; "Special Collections: Photographic Order from Pop to Now" at the International Center for Photography, New York and Fondation Deutsch, Lausanne, Switzerland, among other venues (1992–94); "Typologies: Nine Contemporary Photographers" at the Corcoran Gallery of Art, Washington DC and the San Francisco Museum of Modern Art, among other venues, 1991–92; and "The Encompassing Eye: Photography as Drawing" at the University of Akron, Akron, Ohio and other venues, 1991–93.

Among Fiskin's awards are an Individual Artist's Fellowship (1990) and a Photography Survey Grant (1979–80) from the National Endowment for the Arts, and the Reva and David Logan Grant for New Writing on Photography (1986), administered by the Photographic Resource Center at Boston University.

Selected Bibliography
Bartman, William (ed.), *Judy Fiskin*, with an essay by Christopher Knight and interview by John Divola, A.R.T Press, Los Angeles, 1988.
Drohojowska-Philip, Hunter, "The pleasure posture," *Art Issues*, November/December 1993, pp. 20–3.
Fiskin, Judy, *Some More Art*, Museum of Contemporary Art, Los Angeles, 1992.
Kandel, Susan, "The tiny photographs of Judy Fiskin," *Art Issues*, no. 16, February/March 1991, pp. 16–19.

CHARLES GAINES

Charles Gaines (b. 1944, Charleston, South Carolina) grew up in Newark, New Jersey where he studied at Jersey City College (BA, 1966). He did graduate work in the School of Art and Design at the Rochester Institute of Technology (MFA, 1967). He taught for a year at Mississippi Valley State College in Itta Bena, Mississippi, then for more than twenty years at California State University, Fresno. In 1990, Gaines was made Assistant Program Director, and in 1993 became Program Director for the Program in Fine Arts at California Institute of the Arts in Valencia. He is an avid tennis player.

Since 1969, Gaines's work has been featured in more than thirty solo exhibitions, including a series of shows from 1980 to the present at the John Weber Gallery, New York; "Charles Gaines: A Survey Exhibition, 1979–1991," 1991, at galleries in Paris, New York, and Santa Monica, California; and a 1995 show at the Santa Monica Museum of Art. His work has been included in more than fifty group shows since 1973: among these are the 1975

Biennial at the Whitney Museum of American Art, New York; "New Dimensions in Drawing, 1950–1980," 1981, at the Aldrich Museum of Contemporary Art, Ridgefield, Connecticut; "Process and Construction," 1985, sponsored by the Archives of Contemporary Thought, Brigitte March Gallery, Kunstlerwerkstett and Lenbachaus Museum, Munich, Germany; "No Justice, No Peace," 1992, at the California Afro–American Museum, Los Angeles; and "LAX, The Los Angeles Exhibition," 1992, at the Otis Art Institute Gallery, Los Angeles.

Gaines has been the curator of several exhibitions, including "The Theater of Refusal: Black Art and Mainstream Criticism," organized by the Art Gallery of the University of California, Irvine, which traveled to four other galleries.

Among other awards, Gaines received an Individual Artist Fellowship (1977) from the National Endowment of the Arts.

Selected Bibliography

Brumfield, John, "Marginalia: life in a day of Black LA, or the Theater of Refusal," *Art Issues*, vol. 29, September/October 1993.
Geer, Suvan, "Charles Gaines at Goldeen," *Los Angeles Times*, 19 July 1991.
Gerstler, Amy, review of "Night/Crimes" at the Santa Monica Museum of Art, *Artforum*, September 1995, p. 97.
Gookin, Kirby, *Charles Gaines: A Survey Exhibition, 1979–1991*, Lavignes-Bastille Gallery, Paris; Leo Castelli Gallery, New York; John Weber Gallery, New York; Dorothy Goldeen Gallery, Santa Monica, 1991.
Liebman, Lisa, "Charles Gaines at John Weber and Leo Castelli," *Artforum*, February 1981.

CHARLES GARABEDIAN

Charles Garabedian was born in Detroit, Michigan in 1923. His father, an Armenian immigrant who, according to Garabedian, "never liked it in America," was forced by the Turks to flee his country. When his mother died, Charles, aged two, was sent to an orphanage with his older sisters. Garabedian's father was crippled in a car accident soon after and lost his job at an automobile plant. When Garabedian was nine, the family reunited and moved to Southern California, living on welfare through much of the Depression. He enlisted in the Air Force during the Second World War, serving as a gunner in North Africa. After the War, he went to college on the GI Bill, first studying literature and philosophy at the University of California, Santa Barbara and then transferring to the University of Southern California (BA, History, 1950). He worked on an assembly line for Chrysler and then as a clerk for the Union Pacific Railroad, spending most of his free time

and earnings at the track. He began painting in the mid-1950s after meeting Ed Moses who dragged him along one day to a drawing class taught by Howard Warshaw. At Moses and Warshaw's encouragement, Garabedian enrolled in graduate school at the University of California, Los Angeles in 1957 (MFA, 1961), studying with the painter William Brice for four years.

Since 1965, his paintings have been the focus of more than thirty solo exhibitions, including three shows at the Cejee Gallery, Los Angeles between 1965 and 1967; the Whitney Museum of American Art, New York, 1976; a retrospective "Charles Garabedian: Twenty Years of Work," 1982, at the Rose Art Museum at Brandeis University, Waltham, Massachusetts; and a series of shows since 1979, including "The Archipelago of Time," 1996, at the L.A. Louver Gallery. His works have been included in more than 100 group exhibitions in the United States and Europe since 1982. Notable among these are the "43rd Biennial Exhibition of Contemporary American Art," 1993, at the Corcoran Gallery of Art, Washington DC; "Individuals: A Selected History of Contemporary Art, 1945–1986," 1986, at the Museum of Contemporary Art, Los Angeles; the Biennial exhibitions of 1975 and 1985 at the Whitney Museum of American Art, New York; "The Figure in 20th Century American Art: Selections from the Metropolitan Museum," 1985, New York; and the Venice Biennale in 1976, 1982, and 1984 in Venice, Italy.

Garabedian intermittently taught at many schools and universities between 1959 and 1992. He received a John Simon Guggenheim Foundation Fellowship (1980) and a Fellowship from the National Endowment for the Arts (1977).

Selected Bibliography

Armstrong, Richard, "Chas Garabedian" in *First Newport Biennial: Los Angeles 1984*, Newport Harbor Art Museum, Newport Beach, California, 1984.
Edelman, Robert G., "Report from Washington: the figure returns," *Art in America*, March 1994, pp. 39–43.
Picot, Peirre, *Charles Garbedian, The Archipelago of Time*, L.A. Louver, Venice, California, 1996.
Russell, John, "The Corcoran gives new meaning to 'Biennial'," *New York Times*, 21 November 1993, H39.
Tucker, Marcia, *Paradise Lost/Paradise Regained: American Visions of the New Decade*, XXXXI Biennale di Venezia, Venice, Italy, United States Pavilion (catalog), 1984.
Weissman, Benjamin, "Charles Garbedian: L.A. Louver," *Artforum*, vol XXVII, no. 8, April 1990, p. 183.

JILL GIEGERICH

Jill Giegerich (b. 1952, Chappaqua, New York) hitchhiked with her boyfriend to San Francisco in 1970 and attended several classes at San Francisco City College. After a year at Mount Angel College, an experimental school in Oregon where she had helped to form a conceptual art group, she transferred to the California Institute of Art in Valencia, California, where she studied with Judy Pfaff, Michael Asher, and Vito Acconci and received a BFA (1975) and a MFA (1977). Giegerich is currently a tenured faculty member at the University of California in Riverside. She is married to one of her former teachers at CalArts, figurative artist John Mandel.

Her wall relief "constructions," as she calls them, have been seen in over twelve solo exhibitions since 1980, including "New Works," 1988, at the San Francisco Museum of Art; at Margo Leavin Gallery, 1987 and 1989; Fred Hoffman Gallery, 1991; and the Santa Monica Museum of Contemporary Art, 1995. Her work has also been part of more than fifty group exhibitions since 1977 in the United States as well as in Brazil, Japan, and Italy, including "Constructing A History," 1990, and "Striking Distance," 1988 (traveling), at the Museum of Contemporary Art, Los Angeles; the Biennial exhibition, 1985, at the Whitney Museum of American Art, New York; and "First Newport Biennale 1984: Los Angeles Today" at the Newport Harbor Art Museum, Newport Beach, California.

She has received a Guggenheim Fellowship (1992), an Individual Artist Fellowship from the National Endowment for the Arts (1984) and an Award in the Visual Arts (1986).

Selected Bibliography

Cotter, Holland, "Eight artists interviewed," *Art in America*, no. 5, May 1987, pp. 163–97.
Jones, Amelia, "Allegories of representation," *Visions*, Winter 1988, pp. 20–1.
Kornblau, Gary, "Jill Giegerich," *Art Issues*, no. 5, Summer 1989, p. 21.
Princenthal, Nancy, review, *Art in America*, 75, February 1987, pp. 146–7.
Wilson, William, "Constructing a career," *Los Angeles Times*, Calendar, 7 September 1991, p. 7.

LAWRENCE GIPE

Lawrence Gipe (b. 1962, Baltimore, Maryland) is the son of a writer who moved to Hollywood in 1980 to work in the film industry. Gipe grew up watching countless screenings of old black-and-white movies on "The Late Show" with his father. He attended Virginia Commonwealth University (BFA, 1984) and the Otis Art Institute of Parsons School of Design (MFA,

Connecticut, the Hirshhorn Museum and Sculpture Garden, Washington DC, and the Art Gallery of Ontario, Toronto, Canada. Since 1966, Hockney has designed sets and costumes for more than ten operas performed in the United States and Europe, among them are "Tristan and Isolde" for which he designed the sets at the Los Angeles Music Center Opera in 1987, and he made his first directorial debut for the 1997 revival.

Hockney has received numerous international awards and honors, including the First Annual Award of Achievement by the Archives of American Art in Los Angeles; 12 May 1993 was declared "David Hockney Day" in LA by the Mayor and City Council.

Selected Bibliography

Clothier, Peter, *David Hockney*, Abbeville Press, New York, London, Paris, 1995.
David Hockney: Paintings, Prints and Drawings, 1960–1970, Whitechapel Art Gallery, London; Boston Book and Art, Boston, 1970.
Hockney, David, *Cameraworks*, with an essay by Lawrence Wechsler, Knopf, New York, 1984.
Livingstone, Marco, *David Hockney*, revised and updated edition, Thames and Hudson, London, 1988.
Tuchman, Maurice and Barron, Stephanie (eds), *David Hockney: A Retrospective*, Los Angeles County Museum of Art, Los Angeles; Abrams, New York, 1988.

MARGARET HONDA

Margaret Honda (b. 1961, San Diego) is a native Californian. A third generation Japanese-American, Honda majored in art history and criticism at the University of California at San Diego (BA, 1984). After her first few years of making art, Honda decided to pursue graduate study in material culture at the University of Delaware (MA, 1991). She moved to the Los Angeles area in the early 1990s, and presently teaches at the Otis Art Institute.

Since 1986, her sculpture and installations have been presented in over ten solo exhibitions, including "Recto/Verso," 1994, as part of the Focus Series at the Museum of Contemporary Art, Los Angeles; at the Shoshana Wayne Gallery, Santa Monica, 1993 and 1996; and at the Saxon Lee Gallery, Los Angeles, 1988 and 1989. Honda's work has been included in more than twenty group exhibitions: among these are "Bad Girls West," 1994, at the Wight Art Gallery at the University of California, Los Angeles, "From the Studio: Recent Painting and Sculpture by 20 California Artists," 1992, at the Oakland Museum, Oakland, California, and

"Relocations and Revisions: The Japanese-American Internment Reconsidered," 1992, at the Long Beach Museum of Art, Long Beach, California.

Selected Bibliography

Clearwater, Bonnie, *Abstract Expressions*, Lannan Museum, Lake Worth, Florida, (catalog), 1987.
Greenstein, M. A., "A conversation with Margaret Honda," *Artweek*, vol. 23, no. 22, 1992, pp. 16–17.
Pincus, Robert L., review, *Art in America*, September 1986.
Smith, Elizabeth A.T., *Margaret Honda: Recto Verso*, Museum of Contemporary Art, Los Angeles, 1994.
Turner, Elisa, "The art of seduction," *ARTnews*, Summer 1994, pp. 184–85.

JIM ISERMANN

Jim Isermann (b. 1955, Kenosha, Wisconsin) attended the University of Wisconsin, Milwaukee (BFA, 1977), and arrived in California in 1978 to pursue graduate study at the California Institute of the Arts in Valencia (MFA, 1980). He stayed in LA after falling in love with the architecture, especially coffee shops of the 1950s and 1960s. Isermann has designed calendars, book covers and occasionally painted houses.

Since 1981, his work has been the focus of more than twenty solo exhibitions, including "Suburban," 1984, and "Shag Paintings," 1989, at the Richard Kuhlenschmidt Gallery, Los Angeles and Feature, New York; "Handiwork," 1994, at Feature, New York and Richard Telles Fine Art, Los Angeles; and "Weaves," 1995, at Richard Telles Fine Art, Los Angeles. Since 1980, his work has been included in more than sixty group exhibitions: among these are "Division of Labor: Woman's Work in Contemporary Art," 1995, at the Bronx Museum of the Arts, New York (traveling); "Guys Who Sew," 1994, at the Art Museum, University of California, Santa Barbara; "LAX 94," 1994, at the Los Angeles Municipal Art Gallery; "Representation/Non-Representation," 1990, at the Security Pacific Gallery, Costa Mesa, California; "LA Hot & Cool," 1987, at the List Visual Art Center, Massachusetts Institute of Technology, Cambridge, Massachusetts; and "TV Generations," 1986, at LACE, Los Angeles, California.

In 1993, Isermann was commissioned by the Los Angeles County Metropolitan Transportation Authority to create a permanent installation for the 5th Street Station of the Metro Blue Line. For "Failed Ideals," completed in 1995, Isermann created six different 42-inch-diameter stained glass windows which are

individually mounted on top of steel pylons that rise from the midline of the 5th Street Station platform. Also in 1993, he completed an installation project in Firminy, France, in the last apartment building designed by Le Corbusier.

Among his many awards are fellowships from the National Endowment for the Arts for sculpture (1984) and for painting (1987).

Selected Bibliography

Cooper, Dennis, review, *Art in America*, May 1987.
Duncan, Michael, review, *Art in America*, October 1994.
Knight, Christopher, "Suburban Bauhaus," *Art Issues*, May/June 1994, pp. 29–31.
Myers, Terry, "Painting Camp," *Flash Art*, November/December 1994, pp. 73–76.
Pagel, David, "Jim Isermann's windows on the imagination," *Los Angeles Times*, 24 September 1992.

MIKE KELLEY

Mike Kelley (b. 1954, Detroit, Michigan) is from a blue-collar, Irish Catholic family that was, he says, "very religious, conservative, and emotionally repressed." His father was in charge of maintenance for a school system and his mother worked in a liquor store. A natural-born anarchist, Kelley tells how as a kid growing up he responded to his father's encouragement to "act more normal" by learning to sew, and stitched together a doll that he placed on his father's bed. In his early teens, he began to develop an understanding of art through his immersion in the radical counter culture of the late 1960s, especially psychedelic posters and underground comics. He attended the University of Michigan at Ann Arbor (BA, 1976) and, hating New York and its art scene, went west to Valencia, California (MFA, California Institute of the Arts, 1978). There he found himself at odds with the curriculum, with its stress on Minimalism and Conceptualism. He has taught at various institutions since 1981; he currently teaches at the Art Center College of Design in Pasadena, California, where he has been an instructor since 1987.

Since 1981, Kelley's work has been the focus of more than thirty solo exhibitions in the United States and Europe, including a series of shows between 1983 and 1994 at the Rosamund Felsen Gallery, Los Angeles; the Jablonka Galerie, Cologne, Germany, 1989, 1991 and 1995; a 1993 retrospective organized by the Whitney Museum of American Art, New York which traveled to the Los Angeles County Museum of Art and the Moderna Museet, Stockholm; and a European retrospective

organized by the Museum of Contemporary Art, Barcelona, Spain, 1997, that traveled to Sweden and Holland. His work has been included in over 150 group exhibitions in the United States and Europe since 1979. Notable among these are the Biennial exhibitions of 1985, 1987, 1989, 1991, 1993, and 1995 at the Whitney Museum of American Art, New York; the "43rd Biennale of Venice, Aperto 88," 1988, in Venice, Italy; "Allegories of Modernism," 1992, at the Museum of Modern Art, New York; "Helter Skelter: LA Art in the 1990s," 1992, at the Museum of Contemporary Art, Los Angeles; and "Documenta IX" 1992, in Kassel, Germany.

Kelley has also done more than twenty performance pieces (between 1978 and 1992), made videos (1982–95), acted in ten films made by others, made audio tapes, authored several articles, performed in various noise bands, and curated an exhibition, "The Uncanny," 1993, for Sonsbeek 93 in Arnhem, The Netherlands.

Among his many awards is an Individual Artist Fellowship (1985) from the National Endowment for the Arts. He also participated in "Beyond the Pink Performance Festival" (Los Angeles) in 1998.

Selected Bibliography
Britton, Donald, "Mike Kelley," *Art Issues*, no. 15, December/January 1990–91, p. 37.
Cotter, Holland, "Eight artists interviewed," *Art in America*, May 1987.
Fehlau, Fred, "Presenting Rearwards," *Flash Art*, November/December 1991, p. 164.
Knight, Christopher, "Nothing like a little enlightened impurity," *Los Angeles Times*, 1 July 1994, pp. F1, F20.
Larson, Kay, "A shock to the system," *New York Magazine*, 29 April 1991, pp. 86–7.

DANIEL J. MARTINEZ
Daniel J. Martinez (b. 1957, Los Angeles) studied at the California Institute of the Arts (BFA, 1979). He did post-graduate study with Klaus Rinke in Los Angeles from 1981 to 1982, and was also invited to study at the Kunstacademie, Dusseldorf, West Germany. He has worked as a photographer of art, and taught at numerous colleges and universities. Currently he teaches Studio Art in New Genres at the University of California, Irvine.

Martinez's works have been included in over forty group exhibitions through the 1980s. By 1988 his works were primarily site-specific installations or involved some type of transitory performance. "Ignore the Dents, A Micro Urban Opera" was conceived and directed by him at the historic Million Dollar Theater in downtown Los Angeles, as part of the 1990 LA Festival. He terms himself a Conceptual Cross Media Artist.

Recent public artworks and temporary installations have included *The Westside Three Point Marchers/Los Defiladores Tres Punto Del Westside* and *Consequences of a Gesture* as part of Culture in Action, a Public Art Program of Sculpture, Chicago (1992–93); *Your Move*, 1994–95, a permanent public art installation collaboration with Renée Petropoulos and Roger White, commissioned for the City of Philadelphia Municipal Service Building exterior plaza; *Nine Ways to Improve the Quality of Your Life*, 1991, a series of street banners hung in the well-to-do shopping area of downtown Seattle, commissioned by the Seattle Arts Commission; and the El Segundo Station of the Green Line, commissioned by the Los Angeles County Metropolitan Transportation Authority (1994). His work was also included in "La Biennale di Venezia," 45th International Exhibition, 1993, Venice, Italy, as was his *Study for Museum Tags: Second Movement Overture con Claque-Overture with Hired Audience Members* as part of the 1993 Biennial exhibition at the Whitney Museum of American Art, New York.

Martinez has received project grants from the National Endowment for the Arts (1990), The Rockefeller Foundation, the Norton Family Foundation (1991), and Los Angeles Contemporary Exhibitions (LACE). He has additionally received individual artist fellowships from the National Endowment for the Arts, California Arts Council, Brody Arts Fund, and Art Matters.

Selected Bibliography
Crockett, Tobey, "Daniel Martinez at Robert Berman," *Art in America*, vol. 81, no. 9, September 1993, p. 121.
Jacob, Mary Jane; Brenson, Michael; and Olson, Eva M., *Culture in Action*, Bay Press, Seattle, Washington, 1995.
Kimmelman, Michael, "Of candy bars and public art," *New York Times*, 6 September 1993, sec. 2, pp. 1, 43.
Lacey, Suzanne (ed.), *Mapping the Terrain: New Genres in Public Art*, Bay Press, Seattle, Washington, 1995.
Levi-Strauss, David, *The Things You See When You Don't Have a Grenade!: Daniel J. Martinez*, Smart Art Press, Santa Monica, California, 1996.

MICHAEL C. McMILLEN
Michael C. McMillen (b. 1946, Los Angeles) is a native Californian. As a boy, he often visited the Hollywood movie sets where his father, who was a scenic designer, worked. He remembers growing up next door to the man who made "those amazing electrical machines" that appeared in the Frankenstein movies. Visiting his workroom was an inspiring initiation into the worlds of science, Hollywood, and American folk art. He also recalls the powerful impressions made on him as an eleven year old by visits to the Egyptian rooms of the Metropolitan Museum of Art and to Coney Island on a trip to New York with his father.

McMillen began his college career at Santa Monica City College planning to become a chemical engineer. He transferred to San Fernando Valley State College, changed his major to art, and studied with Walter Gabrielson (BA, 1969). He then attended University of California, Los Angeles (MA, 1972; MFA, 1973). Highly skilled as a model maker, McMillen readily found work in the special effects departments of the movie studios, where he worked on and off for the next fourteen years.

Since 1973, his work has been presented in more than two dozen solo exhibitions in the United States and abroad, including the installation *Inner City*, 1977, at the Los Angeles County Museum of Art, also presented at the Whitney Museum of American Art, New York, 1978; "Michael C. McMillen: Habitats — Installations and Constructions," 1991–92, at the Oakland Museum, Oakland, California; and "Deliverance," 1993, at the L.A. Louver Gallery, Venice, California. His work has been included in more than 100 group exhibitions in the United States, the Far East, and Europe: Notable among these are "Miniature Environments," 1989, at the Whitney Museum of American Art (at Philip Morris); "Forty Years of California Assemblage," 1989, at the Wight Art Gallery of the University of California, Los Angeles; "Red Grooms/Michael C. McMillen: A Collaboration," 1987–88, at the Los Angeles Municipal Art Gallery, Barnsdall Park; "Emerging Artists 1978–1986: Selections from the Exxon Series," 1987, at the Solomon R. Guggenheim Museum, New York; and "Los Angeles Art Today: Contemporary Visions," 1987, at Amerika Haus, West Berlin, Germany.

Among his many awards are Individual Artist Fellowship grants from the National Endowment for the Arts (1978, 1986), and from the Cultural Affairs Department, City of Los Angeles (1996).

Selected Bibliography
Gerstler, Amy, "Michael McMillen — L.A. Louver," *Artforum*, December 1990, pp. 146–7.
Hugo, Joan, *Michael McMillen: His Constructions*, Kukje Gallery, Korea, 1990.
Knight, Christopher, "Behold: a power plant or Frankenstein's lab?," *Los Angeles Herald-Examiner*, 30 October 1980.
Larsen, Susan C., "Michael McMillen," *Arts*,

December 1986, p. 106.
McKenna, Kristine, "He sold his heart to the junkman," *Los Angeles Times*, 28 November 1993.
Morris, Gay, "Michael C. McMillen at the Oakland Art Museum," *Art in America*, July 1992.

TIM MILLER

Tim Miller (b. 1958, Pasadena) is a native Californian. Miller grew up in Whittier, California, the home of President Nixon, in a "Euro-American middle-class family" that was *normal*, the "danger word" as he puts it. His father was a traveling salesman, and his mother worked behind the counter at May Company. After a "bratty Dostoevskian" adolescence, Miller fled to New York in 1978 wanting to "do the postmodern art dance thing." In 1980, along with co-founders Charles Moulton and Charles Dennis, Miller created PS 122 on the Lower East Side. In 1986, Miller moved to Los Angeles with his dog Buddy and his boyfriend. In 1990, he was one of the "NEA Four" whose fellowship recommendations were overturned due to their controversial content. Their ensuing lawsuit against the government resulted in the National Endowment for the Art's "decency" requirements being ruled unconstitutional by a series of lower circuit court rulings. Miller has been artist-in-residence at Highways, the Californian performance space of which he is founding Artistic Director. Miller currently teaches performance workshops at Highways, and is Adjunct Professor in the Graduate Theater Program at the University of California, Los Angeles.

His performances have been presented throughout the United States and Europe, including productions at the Brooklyn Academy of Music NEXT WAVE Festival, the Copenhagen International Theater Festival, the London Institute for Contemporary Art, the Walker Art Center, Minneapolis, Minnesota, the New York International Festival, and many less recognized venues. Original performances include *Fruit Cocktail*, 1996, at the Huntington Beach Art Center, *Sex/Love/Stories*, 1992, at PS 122, *My Queer Body*, 1992, Charles Playhouse, Boston, Massachusetts, and *Stretch Marks*, 1989, at Highways.

Miller is a member of ACT UP/LA (AIDS Coalition to Unleash Power) and has been arrested numerous times in acts of civil disobedience all over the United States in efforts to force more government attention to AIDS. He has been awarded numerous grants for his performance art by the National Endowment for the Arts and the California Arts Council.

Selected Bibliography
Corey, Frederick, "Gay life/queer art," in *The Last Sex: Feminism and Outlaw Bodies*, New World Perspectives, Montreal, 1993.
Goodman, Lizbeth, "Death and dancing in the live arts: performance, politics and sexuality in the age of AIDS," *Critical Quarterly*, vol. 35, no. 2, Summer 1993.
Roman, David, "Performing all our lives: AIDS, performance, community" in *Critical Theory and Performance*, University of Michigan Press, Detroit, 1992.

RENÉE PETROPOULOS

Renée Petropoulos (b. 1954, Los Angeles) is a native Californian. Her parents, Greek and German immigrants, divorced when she was three, and she was raised by her mother and her mother's parents. Encouraged as a child by her family to make art, she did not realize that one "could *be* an artist" until she began meeting "living" artists like Alexis Smith and Laddie Dill while working at the then-new L.A. Louver Gallery in the mid 1970s. Before that, she had majored in art history, with an emphasis on Islamic art, at the University of California, Los Angeles (BA, 1974). She did graduate work at UCLA (MA, 1977; MFA, 1979), where she studied with Tom Wudl and Robert Fichter. Since 1976, she has taught at various institutions, primarily Otis Art Institute in Los Angeles and the Art Center College of Design in Pasadena.

Petropoulos's work has been the focus of over seventeen solo exhibitions since 1980, including "Set Free to Roam the World: A Study in Similarities and Differences," 1989, "The Chicken or the Egg," 1991, "In memory of: In hope of," 1993, and "Show Us Their Faces, Tell Us What They Said," 1995, all at the Rosamund Felsen Gallery, Los Angeles. Since 1978, her work has been included in more than forty group exhibitions.

Petropoulos has also worked on numerous private commissions and public art projects. Realized projects include the Los Angeles Central Public Library (1990–93), the Douglas Station on the Green Line of the Los Angeles County Metropolitan Transportation Authority (1990–95), and several collaborations with Daniel J. Martinez and Roger White, most recently "Your Move" (1996) on the exterior plaza of the Municipal Services Building in Philadelphia.

She was the curator of "Neotoma," 1995, at the Otis College of Art and Design, Los Angeles, and "Interiors: Francis Alÿs, Kevin Appel, Robin Tewes," 1996, at Los Angeles Contemporary Editions (LACE). Among her awards are a Djerassi Foundation Fellowship (1989) and an Art Matters Inc. Grant (1995).

Selected Bibliography
Adams, Gerald D., "Howard Street arch plan promises long, hot debate," *San Francisco Examiner*, 1 August, 1991, A11.
Duncan, Michael, "LA rising," *Art in America*, December 1994, pp. 72–83.
Knight, Christopher, "The library's most valuable additions," *Los Angeles Times*, 6 October 1993, pp. 1, 3.
Sozanski, Edward J., "It's 'Your Move' as a Plaza Turns into a Big Game Board," *Philadelphia Inquirer*, 12 June 1996, pp. A1, B1.
Weissman, Benjamin, "Renée Petropoulos," *Artforum*, May 1989, pp. 161–2.

LARI PITTMAN

Lari Pittman (b. 1952, Los Angeles) is a native Californian. He is the "hybrid" son, as he puts it, of an Anglo, Presbyterian father and a Colombian-born, Catholic mother. His mother's background offered him a standpoint from which he began to question the dominant Protestant heritage of American culture, with its work ethic and attitudes towards sex, death, and love.

Pittman attended the University of California, Los Angeles from 1970 to 1973, and then the California Institute of the Arts in Valencia (BFA, 1974; MFA, 1976). As a student at CalArts, Pittman was influenced by the multimedia experiments in pattern and decoration art by members of the Feminist Art Program, run by Miriam Schapiro and Judy Chicago. He has been a tenured professor in the Fine Arts Department at the University of California, Los Angeles since 1993.

Pittman's paintings have been the focus of over twenty solo exhibitions since 1982, including a series of shows at the Rosamund Felsen Gallery, Los Angeles between 1983 and 1993; the Jablonka Galerie, Cologne, Germany, 1993; at Jay Gorney Modern Art, New York, 1994; and a mid-career survey at the Los Angeles County Museum of Art, 1996 (traveling). Since 1976, his work has been included in more than seventy group exhibitions in the United States, Europe, and Mexico, including four Biennial exhibitions (1987, 1993, 1995, 1997) at the Whitney Museum of American Art, New York and "Helter Skelter: LA Art in the 1990s," 1992, at the Museum of Contemporary Art, Los Angeles.

Among his awards are Fellowships from the National Endowment for the Arts (1987, 1989, 1993).

Selected Bibliography
Cameron, Dan, "Sweet thing," *Artforum*, December 1992.

Cooper, Dennis and Yancey, C., "Lari Pittman: the august vigilante," *Artforum*, December 1992.
Duncan, Michael, "LA rising," *Art in America*, December 1994.
Fox, Howard, *Lari Pittman*, with contributions by Dave Hickey and Paul Schimmel, Los Angeles County Museum of Art, Los Angeles, 1996.
Jones, Amelia, "Lari Pittman's queer feminism," *Art + Text*, 50 (Sydney, Australia), January 1995, pp. 36–42.
Knight, Christopher, *Lari Pittman Paintings*, Galerie Krinzinger, Vienna, Austria, 1992.
Scarborough, James, "Lari Pittman at Rosamund Felsen," *Art Press* (Paris), November 1994.

CHARLES RAY

Charles Ray (b. 1953, Chicago, Illinois) attended the University of Iowa (BFA, 1974) and Mason Gross School of the Arts, Rutgers University, New Brunswick, New Jersey (MFA, 1978). His activities between 1975 and 1979 are somewhat unclear. He has lived in the general LA area since 1980. He once borrowed a sports coat from the author for the strange bachelor party of an internationally known contemporary art dealer.

Since 1983, Ray's work has been the focus of over twenty-five solo exhibitions in the United States and Europe, including a series of shows at Feature, New York, between 1989 and 1993; at the Burnett Miller Gallery, Los Angeles, between 1987 and 1990; and the survey "Charles Ray," 1994, organized by the Rooseum — Center for Contemporary Art, Malmo, Sweden, and which traveled to the ICA, London, the Kunsthalle Bern, and the Kunsthalle Zurich. A retrospective survey was also organized for the Whitney Museum of American Art, New York (1998), Museum of Contemporary Art, Los Angeles (1998), and Museum of Contemporary Art, Chicago (1999). Since 1980, his work has been included in more than forty group shows in the United States and Europe: among these are the Biennial exhibitions at the Whitney Museum of American Art, New York, in 1997, 1993, and 1989; "Documenta IX," 1992, in Kassel, Germany; "Helter Skelter: LA Art in the 1990s," 1992, at the Museum of Contemporary Art, Los Angeles; and "Katarina Fritsch, Robert Gober, Reinhard Mucha, Charles Ray, and Rachel Whiteread," 1991, at the Luhring Augustine Gallery, New York.

Selected Bibliography

Barnes, Lucinda, *Charles Ray*, Newport Harbor Art Museum, Newport, California, 1990.
Bonami, Francesco, "Charles Ray: a telephone conversation," *Flash Art*, Summer 1992, pp. 98–100.
Ferguson, Bruce W., *Charles Ray*, Rooseum — Center for Contemporary Art, Malmo, Sweden, 1994.
Pagel, David, "Charles Ray," *Art Issues*, May/June 1992, pp. 32–3.
Relyea, Lane, "Charles Ray: in the NO," *Artforum*, September 1992, pp. 62–6.
Schimmel, Paul, *Charles Ray*, with essay by Lisa Phillips, Museum of Contemporary Art, Los Angeles, and Scalo Verlag, Zurich, 1998.

FRANK ROMERO

Frank Romero (b. 1941, Los Angeles) was one of the founding members of *Los Four*, a collective formed along with Carlos Almaráz, Gilbert Luján, and Beto de la Rocha, who desired to help define and promote a new awareness of *La Raza* through murals, publications, and exhibitions. *Los Four* was the first Chicano group to have an exhibition in a major art museum, at the Los Angeles County Museum of Art in 1974, and they continued to exhibit at other museums, universities, and galleries until the early 1980s.

Since 1980 Romero has balanced his efforts between public commissions and personal work. Since 1977 his work has been presented internationally in more than thirty solo exhibitions and over seventy group exhibitions. Central to his individual exhibitions are shows at the Robert Berman Gallery (1987, 1991, 1992, 1995). Among his many groups exhibitions are "Chicanarte," 1975, at the Los Angeles Municipal Art Gallery, "Hispanic Art in the United States," 1987 (traveling), at the Corcoran Gallery, Washington DC, and "Le Demon des Anges," 1989 (traveling), at Hallu du CRDC, Nantes, France.

Romero has been principally responsible for or participated in the creation of many murals including *El Salvador*, 1990, *Going to the Olympics*, 1984, and *Niño y Caballo*, 1984, in Los Angeles. He has participated in many public art commissions such as being a member of the design team for CALTRANS stations in San Francisco (1986).

Selected Bibliography

Beardsley, John, *Hispanic Art in the United States*, Abbeville Press, New York, 1987.
Cockroft, Eva, "Chicano identities," *Art in America*, June 1992.
Hopkins, Henry, *California Painters: New Work*, Chronicle Books, San Francisco, 1989.
Marrow, Marva, *Inside the LA Artist*, Peregrine Smith Books, Salt Lake City, Utah, 1988.
National Museum of American Art at the Smithsonian, Bullfinch Press, Little, Brown and Company, Washington DC, 1995.

NANCY RUBINS

Nancy Rubins (b. 1952, Naples, Texas) was the youngest of three children. Her family frequently relocated, following her father's career as a research engineer, and most of her childhood was spent in the tiny town of Tullhoma, Tennessee. She spent two years at Peabody College in Nashville studying to become an art teacher before transferring to the Maryland Institute College of Art in Baltimore (BA, 1974) and then on to the University of California at Davis (MFA, 1976). From there she moved to San Francisco and worked as a waitress during the day and taught painting at night at the San Francisco Art Institute. She has taught at various schools across the country since, and has been on the art department faculty at the University of California, Los Angeles since 1988. She is married to artist Chris Burden.

From 1980 to 1982 Rubins completed several monumental works in New York, a few of which were done through the art program "Creative Time." One of her notable public works was a permanent commission for a shopping center in Chicago that became controversial. This project then led to a commission from Washington Project for the Arts. *World's Apart*, a gargantuan 40-foot-high mushroom-shaped orb of appliances perched on a thick stem, on a plot of land near the Watergate building, proved to be less than popular.

Rubins has been featured in over twenty solo exhibitions in the United States and Europe including the Galeries Patrick de Brock, Antwerp, Belgium, 1992; Burnett Miller Gallery, Los Angeles, 1992; the Museum of Contemporary Art, San Diego, 1995; and "Projects 49: Nancy Rubins," 1995, at the Museum of Modern Art, New York. Her over thirty group exhibitions since 1977 include "Helter Skelter: LA Art in the 1990s," 1992, at the Museum of Contemporary Art, Los Angeles; "Aperto," 1993, 45th Venice Biennale, Venice, Italy; and the 1995 Biennial exhibition at the Whitney Museum of American Art, New York.

Among numerous awards, Rubins received grants from the National Endowment for the Arts (1977, 1980) and the Flintridge Foundation (1998).

Selected Bibliography

Conkelton, Sheryl, *Project 49: Nancy Rubins*, Museum of Modern Art, New York, 1995.
Kano, Kathryn et al., *Nancy Rubins*, Museum of Contemporary Art, San Diego, 1995.
Kertess, Klaus et al., *1995 Biennial Exhibition*, Whitney Museum of American Art, New York, 1995.
Schimmel, Paul et al., *Helter Skelter: LA Art in the 1990s*, Museum of Contemporary Art, Los Angeles, 1992.

ED RUSCHA

When Edward Ruscha (b. 1937, Omaha, Nebraska) was five years old, his family moved to Oklahoma City where his father, a devout Catholic, worked as an insurance auditor. Ruscha began making art when he was ten, doing several large paper murals at school with his classmate Mason Williams and beginning to draw comics. After graduating from high school, Ruscha drove with Williams to Los Angeles, intending to become a commercial artist. He enrolled at Chouinard Art Institute which he attended until 1960, when he began working full-time for an advertising agency doing layout and graphics. Hating the work, Ruscha left after a year and spent six months traveling in Europe. Beginning in 1965, he did layouts for *Artforum* for two years, using the pseudonym Eddie Russia.

Since 1963, Ruscha's work has been featured in more than 100 solo exhibitions in the United States and Europe, including retrospectives in 1982–83, organized by the San Francisco Museum of Modern Art and traveling to the Whitney Museum of American Art, New York, the Vancouver Art Gallery, British Columbia, the Contemporary Arts Museum, Houston, Texas, and the Los Angeles County Museum of Art; and in 1989–90, organized by the Musée National d'Art Moderne, Centre Georges Pompidou, Paris and traveling to Rotterdam, Barcelona, London, and the Museum of Contemporary Art, Los Angeles. His work was featured in a series of shows from 1972 to 1995 at the Castelli Gallery, New York; and at the Ferus Gallery, Los Angeles between 1963 and 1965. Since 1962, Ruscha's work has been included in more than 200 group exhibitions, most recently the Biennial exhibition at the Whitney Museum of American Art, New York (1997).

In 1963, Ruscha published his first book, *Twentysix Gasoline Stations*; he has since published more than fifteen others, including *Every Building on Sunset Strip*, 1966, *Thirtyfour Parking Lots in Los Angeles*, 1967, and *Nine Swimming Pools*, 1968. He has executed several public commissions, including the *Rotunda Mural*, 1985, and *Lunettes*, 1989, for the Miami-Dade Art in Public Places Trust for the Miami-Dade Public Library, Florida. Ruscha as public art appears as a full-length portrait on a nine-story building in downtown Los Angeles, painted by artist Kent Twitchell.

Among Ruscha's awards are Individual Artist Fellowships from the National Endowment for the Arts (1969, 1978) and a Fellowship from the Guggenheim Foundation (1971). He was also a recipient of the California Arts Council Governor's Award for Achievement in the Visual Arts (1995).

Selected Bibliography

Clearwater, Bonnie, and Knight, Christopher, *Edward Ruscha: Words Without Thoughts Never to Heaven Go*, Lannan Museum, Lake Worth, Florida, 1988.
De Groot, Elbrib (ed.), *Edward Ruscha*, Museum Boymans-van Beuningen, Rotterdam, The Netherlands, 1990.
Hickey, Dave, and Plagens, Peter, *The Works of Edward Ruscha*, introduction by Anne Livet and foreword by Henry T. Hopkins, San Francisco Museum of Modern Art, San Francisco, 1982.
Stockebrand, Marianne, *Ed Ruscha: 4x6*, translated by Brigitte Kalthoff, Westfalischer Kunstverein, Munster, West Germany, 1986.

BETYE SAAR

Betye Saar (b. 1926, Los Angeles) is a native Californian of African, Irish, and Native American descent. As a child, she would spend time during her parents' vacations at her grandmother's home in Watts, searching out and collecting objects like beads, stones, and bits of glass, which she invested with a supernatural aura. Her fascination with this magical debris was reinforced on walks with her grandmother, as they watched Simon Rodia's building of the Watts Towers, "a fairytale palace" to her. Saar studied at the University of California, Los Angeles (BA, 1949) and went to work as a designer. Starting in 1958, she pursued graduate studies at California State University, Long Beach (1958–62), at the University of Southern California (1962), and at California State University, Northridge (1966). Seeing a 1968 exhibition of Joseph Cornell's work at the Pasadena Art Museum was an inspiration to her work, she recalls.

Since 1971, Saar's work has been the focus of more than fifty solo exhibitions in the United States and the Far East, including "Africus Biennale," 1995, Johannesburg, South Africa; "Limbo," 1994, at the Santa Monica Museum of Art, Santa Monica, California; "Sanctified Visions," 1990, and "In Context," 1984, at the Museum of Contemporary Art, Los Angeles; a 1977 show at the San Francisco Museum of Modern Art; and a 1975 show at the Whitney Museum of American Art, New York. Since 1968, Saar's work has been included in more than sixty group exhibitions in the United States, Europe, South America, South Africa, and Canada: among these are "John Otterbridge and Betye Saar," 1994; the 22nd Biennial of Sao Paulo at the Museum of Modern Art, Sao Paulo, Brazil; and "Secrets, Dialogues, Revelations: The Art of Betye and Alison Saar," 1990–91, shown at six museums around the United States. Saar was one of the original artists involved in "The Power of Place" collaboration about Biddy Mason in downtown Los Angeles. She has also been awarded public art commissions in Miami, Florida and Newark, New Jersey.

Among her many awards are an Honorary Doctorate Degree from the California Institute of the Arts in Valencia (1995), a John Simon Guggenheim Memorial Foundation Fellowship (1991), Fellowships from the National Endowment for the Arts (1974, 1984), and a Visual Artist Award from the Flintridge Foundation (1998).

Selected Bibliography

Davis, Zina, *Betye Saar — Signs of the Times*, Hypo-Bank, New York, 1992.
Editorial, "Fetishes and facts on her canvases," *Star-Trends*, Johannesburg, South Africa, 10 March 1995, p. 9.
Hopkins, Henry, and Jacobs, Mimi, *50 West Coast Artists*, Chronicle Books, San Francisco, 1981.
Hough, Katherine Plake, and Cove, Roberta Arnold, *Return of the Narrative*, Palms Springs Desert Museum, Palm Springs, 1984.
Lefalle-Collins, Lizetta, *The Art of Betye Saar & John Otterbridge*, 22nd International Biennial of San Paulo, Brazil, 1994.
Wilson, William, "Limbo: Saar's signature on the shadows of reality," *Los Angeles Times*, 6 June 1994, p. F4.

ADRIAN SAXE

Adrian Saxe (b. 1943, Glendale) is a native Californian. Both of Saxe's parents worked in the field of popular and commercial art — his mother was a cel colorist for the Walt Disney Studio; his father was a licensed embalmer and, later, a photographer — and it was from them that he learned craft technique and respect for handmade objects. In 1960, the family moved to Hawaii where Saxe spent two years at university, majoring in inorganic chemistry and minoring in art. He returned to California in 1962, setting up a ceramics studio in Costa Mesa with his former teacher, Orville Clay. An automobile accident prevented him from joining the recently established Berkeley group of Peter Voulkos and, after a year of being unable to make art, Saxe re-entered school, first at Los Angeles City College and then in 1965 at Chouinard Art School in Los Angeles. After a hiatus of several years, he received a BFA (1974) from Chouinard's later incarnation, the California Institute of the Arts in Valencia. Saxe has taught at the University of California, Los Angeles since 1973, and is presently the head of the ceramics program in the art department.

Since 1973, his work has been the focus of

more than twenty solo exhibitions including the retrospective "The Clay Art of Adrian Saxe," 1994, organized by the Los Angeles County Museum of Art, which traveled to the Museum of Contemporary Ceramic Art in the Shigaraki Ceramic Cultural Park, Japan, and a series of shows from 1982 through 1995 at the Garth Clark Gallery, Los Angeles and New York. His work has been included in more than fifty group exhibitions in the United States, Europe, and Asia since 1971. Notable among these are the 1994 Taipei International Exhibition of Ceramics at the Taipei Fine Arts Museum, Taiwan; "New Craft Forms — Nytt Kunsthandverk," 1994, at the Malhaugen Museum, Lillehammer, Norway, an event of the Winter Olympics Arts Festival; "Contemporary Crafts and the Saxe Collection," 1993, organized by the Toledo Museum of Art, Ohio; and "Art That Works: The Decorative Arts of the Eighties, Crafted in America," 1990 (traveling), organized by Arts Services International, Alexandria, Virginia.

Selected Bibliography

Clark, Garth, *American Ceramics: 1876 to the Present*, Abbeville Press, New York, 1987.
Knight, Christopher, "Adrian Saxe I" and "Adrian Saxe II" in *Last Chance for Eden: Selected Art Criticism of Christopher Knight*, Malin Wilson (ed.), Art Issues Press, Los Angeles, 1995.
Lynn, Martha Drexler, *The Clay Art of Adrian Saxe*, with a contribution by Jim Collins, Los Angeles County Museum of Art, Los Angeles; Thames and Hudson, New York, 1993.
Peterson, Susan, *The Craft and Art of Clay*, Prentice Hall, Englewood Cliffs, New Jersey, 1992.

ILENE SEGALOVE

Ilene Segalove (b. 1950, Los Angeles) is a native Californian. Growing up in Beverly Hills, in the shadow of Hollywood's glare, Segalove became aware at a young age of the power of television and of the strange, often humorous conjunctions of TV images and everyday life. In Jewish nursery school, her first assignment was to draw a picture of God: the drawing she made, an image of a black-and-white eyeball floating in a gray sky, turned out to be the CBS logo. She dates her artistic interest in TV to seeing, for the first time, her father cry while watching the televised funeral of John F. Kennedy. A few years later, she was asked out on a date by the stand-in for Dustin Hoffman, who was filming *The Graduate* across the street in a house that was the mirror-image of her parents' house.

Segalove attended the University of California, Santa Barbara (BA, 1972) and began studying communication arts at Loyola University in Los Angeles (MA, 1975). At the same time, she audited classes given by John Baldessari at CalArts and worked as his assistant.

Since 1972, her video works have been included in more than 100 exhibitions and broadcasts in the United States, Europe, and throughout the world, including the retrospective "Why I Got into TV and Other Stories," 1990, organized by the Laguna Art Museum, California; "Suburban Home Life: Tracking the American Dream," 1989, at the Whitney Museum of American Art, New York; a showing of "Illuminations: My Puberty" on Channel 4 Television in London in 1988; the exhibit "More TV Stories," 1988, at Kijkhuis in The Hague, The Netherlands; "Contemporary Southern Californian Art," 1987, at the Taipei Fine Arts Museum, Taiwan; and "Video-Biennale," 1985, in Vienna.

She has also shown her photographic and mixed-media work in more than fifty exhibitions since 1972, including the solo show "Silent Conversations: New Photographic Stories," 1993, at the Julie Rico Gallery, Los Angeles, and made twenty radio broadcasts between 1985 and 1989, mostly for National Public Radio and the Canadian Broadcasting Co.

Her awards include fellowships from the National Endowment for the Arts in Video (1976, 1979, 1983, 1984) and in Media/Radio (1987, 1994), a Young Talent Award (1986) from the Los Angeles County Museum of Art, and an Independent Filmmaker Award from the American Film Institute (1981).

Selected Bibliography

Darling, Lowell, and Desmarais, Charles, *Ilene Segalove — Why I Got into TV and Other Stories*, Laguna Art Museum, Laguna, California, 1990.
Larsen, Susan, "The Nation — Los Angeles: a fantasy life," *Art News*, 78, no. 5, May 1979, pp. 117–24.
Reidy, Robin, "TV stories: the adventures of Ilene Segalove," *Afterimage*, 14, no. 3, October 1986, pp. 4–5.
Renov, Michael, "The subject in history: the new autobiography in film and video," *Afterimage*, 17, no. 1, Summer 1989, pp. 4–7.

PETER SHELTON

Peter Shelton (b. 1951, Troy, Ohio) grew up in Tempe, Arizona. His father's partial paralysis, the result of a Second World War wound, contributed to Shelton's early awareness of his own body, of its anatomy and maneuverability. As a boy, he built fantasy environments of different sorts — tree forts, clubhouses, and Christmas displays on the lawn. Shelton came to Southern California in 1969 when he entered Pomona College as a premed student, aiming to follow in the footsteps of his physician grandfather. After experimenting with various majors, including sociology and theater, Shelton settled on fine arts, studying with James Turrell and Michael Brewster (BA, 1973, Pomona). After graduation, he returned to his native Troy, where he enrolled in the Hobart School of Welding Technology, receiving trade certification in 1974. He then worked for several years in the midwest as a professional welder before returning to graduate school at the University of California, Los Angeles in 1978, where he worked with Lee Mullican and William Brice (MFA, 1979).

Since 1979, Shelton's work has been featured in more than thirty solo exhibitions, including "Peter Shelton: bottlesbonesandthingsgetwet," 1994, at the Los Angeles County Museum of Art; numerous exhibitions at L.A. Louver Gallery since 1984 including "floatinghouse, DEADMAN," 1990, at L.A. Louver Gallery, New York; and "BLACKVAULT falloffstone: Sculpture Inside Outside," 1988, at the Walker Art Center, Minneapolis, Minnesota. Since 1977, his work has been included in more than fifty group exhibitions in the United States, Europe, and Japan. Notable among these are "LAX: 92" at the Municipal Art Gallery, Barnsdall Art Park, Los Angeles, 1992; "Elements: Five Installations" at the Whitney Museum of American Art, New York, 1988; and "Aperto 84" at the Venice Biennale, 1984.

Among Shelton's awards are Individual Artist Fellowship Grants from the National Endowment for the Arts (1980, 1982, 1984), and a John Simon Guggenheim Memorial Foundation Fellowship (1989).

Selected Bibliography

Eliel, Carol S., *Peter Shelton: bottlesbonesandthingsgetwet*, Los Angeles County Museum of Art, Los Angeles, (catalog), 1994.
Halpern, Nora, "Peter Shelton — L.A. Louver," *Flash Art*, May/June 1992.
Marks, Ben, "Peter Shelton: body language," *Angeles*, January 1991.
Rico, Diana, "How to dance like Buddha," *ARTnews*, October 1994.
Shimizu, Tetsuro, "Individual realities in the California scene," Sezon Museum of Art, Tokyo, Japan, (catalog), 1991.

PETER SHIRE

Peter Shire (b. 1947, Los Angeles) is a fourth-generation Californian. His parents were both labor organizers. One of Shire's grandfathers was a cabinetmaker, the other a furniture designer. Shire's father was also a skilled carpenter and, as a boy, Shire spent his

summers working in his father's shop, learning aspects of the building trades and furniture design.

He studied at Chouinard Art Institute in Los Angeles (BFA, 1970) where he was influenced by the ideas and work of Peter Voulkos, John Mason, and especially Kenneth Price who together, a decade earlier at Otis Art Institute, had transformed the artistic possibilities of ceramic sculpture. Shire was one of the founding artists of the Italian-based design group, Memphis, which was formed in 1980. Since 1981, he has taught at a number of art schools, including UCLA, the Southern California Institute of Architecture and, most recently, the University of Southern California.

Since 1975, his work has been the focus of more than thirty solo exhibitions, including "Ceramic Freeways: A Ten Year Teapot Retrospective," 1988, at the Los Angeles Municipal Art Gallery; at the Nevada Institute for Contemporary Art at the University of Nevada, Las Vegas, 1988; Clara Scremini Gallery, Paris, France, 1989; Design Gallery Milano, Milan, Italy, 1989; Gallery Saito, Sapporo, Hokkaido, Japan, 1995; and the William Traver Gallery, Seattle, Washington, 1996.

Shire was a member of the design team of the American Institute of Architects for the XXIII Olympiad in Los Angeles in 1984. He has worked on many public commissions since 1982. These include the Domino Towers for Hokuden Electric in Sapporo, Hokkaido, Japan (1992), the Wilshire/Vermont Station for the Los Angeles County Metropolitan Transportation Authority (1995), the Union Plaza Gateway for Catellus Corporation in Los Angeles (1995), and the Hope Street Promenade (1995) for the Community Redevelopment Agency of Los Angeles.

Selected Bibliography
Clothier, Peter, "A carnival world of color," *American Ceramics*, April 1990, pp. 27–33.
Drohojowska, Hunter, and Klein, Norman, *Ceramic Freeways: Peter Shire, A Ten Year Teapot Retrospective*, introduction by Ettore Sottsass, Los Angeles Municipal Art Gallery, Los Angeles, 1988.
Porges, Maria, "Peter Shire: free way," *American Craft*, December/January 1988/1989, pp. 50–5, 69.
Tempest in a Teapot, Ceramic Art of Peter Shire, Rizzoli International Publications, New York, 1991.

ALEXIS SMITH
Alexis Smith (b. 1949, Los Angeles) is a native Californian. Born Patricia Anne Smith, she changed her name after high school to Alexis, after the movie star. Smith grew up on the grounds of a mental hospital in Norwalk, California, where her father, a psychiatrist, was assistant superintendent. It was, she says both a "peculiar" and "protected" environment, a kind of "walled city." Her mother died when she was eleven, and Smith, an only child, recalls her time being filled with cutting up and pasting together things she collected, watching TV sitcoms, and listening to her father's stories about growing up in the West (Utah) and about American history. Smith attended the University of California at Irvine (BA, 1970). She entered as a French major and switched to art after a couple of years, studying with Robert Irwin and Vija Celmins. Smith has held various teaching positions since 1975, including two three-year stints at the University of California, Los Angeles; in 1993, she was Meadows Distinguished Visiting Professor at Southern Methodist University in Dallas, Texas.

Since 1974, Smith's work has been the focus of more than forty solo exhibitions, including a series of shows from 1982 to the present at the Margo Leavin Gallery, Los Angeles; "Viewpoint: Alexis Smith," 1986, at the Walker Art Center, Minneapolis, Minnesota; "Past Lives," 1989, in collaboration with the poet Amy Gerstler at the Santa Monica Museum of Art, Santa Monica, California; and the retrospective "Alexis Smith," 1991–92, shown at the Whitney Museum of American Art, New York and the Museum of Contemporary Art, Los Angeles. Since 1972, her work has been included in over 100 group exhibitions. Notable among these are the Biennials of 1975, 1979, and 1981 at the Whitney Museum of American Art, New York; "Verbally Charged Images," 1984, which traveled to six museums and university galleries in the United States; "Individuals: A Selected History of Contemporary Art 1945–1986," 1986, at the Museum of Contemporary Art, Los Angeles; "Striking Distance," 1988, at the Museum of Contemporary Art, Los Angeles; "Forty Years of California Assemblage," 1989, at the Wight Art Gallery at the University of California, Los Angeles; and "Proof: Los Angeles Art and the Photograph, 1960–1980," 1992–93 (traveling), at the Laguna Art Museum, Laguna, California.

Smith has been awarded eleven public commissions, including *The Grand* (1983), a painted installation in the Keeler Grand Foyer of DeVos Hall, Grand Center, Grand Rapids, Michigan; *Snake Path* (1992), a slate, concrete, and granite work for the Stuart Collection of the University of California at San Diego, La Jolla, California; and the terrazzo floor designs for the south and west lobbies of the Los Angeles Convention Center Expansion Project (1993). She has also produced a number of artist's books and commissioned graphics.

Works from Smith, David Hockney, and Ed Ruscha were commissioned for buildings of the new Getty Center.

Among her awards are Fellowships from the National Endowment for the Arts (1976, 1987).

Selected Bibliography
A Brave New World: John Baldessari/Vernon Fisher/Stephen Prina/Ed Ruscha/Alexis Smith, Karsten Schubert Ltd., London, 1989.
Alexis Smith: Public Works, Mandeville Gallery, University of California, San Diego, La Jolla, California, 1991.
Alexis Smith Retrospective, Whitney Museum of American Art, New York, and Museum of Contemporary Art, Los Angeles, 1991.
Crossing the Line: Word and Image in Art 1960–1990, Montgomery Gallery, Pomona College, Claremont, California, 1990.
Hollywood, Hollywood, Alyce de Roulet Williamson Gallery, Art Center College of Design, Pasadena, California, 1992.

ROBERT THERRIEN
Robert Therrien (b. 1947, Chicago, Illinois) was educated in California. He started out in Santa Barbara, and worked his way down to Los Angeles (MFA, 1974, University of Southern California). He relishes privacy.

Since 1977, Therrien's work has been featured in over twenty solo exhibitions in the United States and Europe, including a series of shows at the Leo Castelli Gallery, New York between 1986 and 1996; the Contemporary Arts Center, Cincinnati, Ohio, 1997; the Museo Nacional Centro de Arte Reina Sofia, Madrid, Spain, 1991–92; and the Museum of Contemporary Art, Los Angeles, 1984. Since 1974, his work has been included in more than fifty group exhibitions in the United States and Europe, including "Carnegie International" at the Carnegie Museum of Art, Pittsburgh, Pennsylvania, 1995–96; "Documenta IX" at the Museum Fridericianum, Kassel, Germany, 1992; "Vital Signs" at the Whitney Museum of American Art, New York, 1988; and the 1985 Biennial exhibition at the Whitney Museum of American Art, New York.

Therrien has worked on several book projects including *Dream Hospital* (Robert Therrien, John Yau, Jacob Samuel, Santa Monica, California, 1995); *Mesa Verde* (Evan Cornell, Robert Therrien, Whitney Museum of American Art, New York, 1993) and *7 & 6* (Michael Butor, Robert Creely, Robert Therrien, Lise Hoshour, Albuquerque, New Mexico, 1989).

Selected Bibliography
Brown, Julia, *Robert Therrien*, Museum of Contemporary Art, Los Angeles, 1984.

Iannaccone, Carmine, "Robert Therrien," *Art Issues*, no. 26, January/February 1993.
Individuals: A Selected History of Contemporary Art, 1945–86, Museum of Contemporary Art, Los Angeles, 1986.
Ratcliff, Carter, *Lynda Benglis, John Chamberlain, Joel Fisher, Mel Kendrick, Robert Therrien*, Magasin 3 Stockholm, Stockholm, 1988.
Rowell, Margit, *Robert Therrien*, Museo Nacional Centro de Arte Reina Sofia, Madrid, 1991.

BILL VIOLA

Bill Viola (b. 1951, New York) realized his video performance aspirations at an early age when he was named captain of the "TV Squad," by his fifth grade class at PS 20 in Queens, New York.

Viola attended the College of Visual and Performing Arts at Syracuse University, New York (BFA, 1975), and from 1973 to 1980 studied and performed with composer David Tudor and the new music group *Rainforest* (later called *Composers Inside Electronics*). During this time he was also an artist-in-residence at WNET Thirteen Television Laboratory in New York.

In 1976 he traveled to the Solomon Islands in the South Pacific to record traditional music and dance and document the Moro cult movement. In 1977 he traveled to Java, Indonesia to record traditional performing arts, and also in 1977, to Australia where he met Kira Perov, arts administrator and photographer; they begin to live, travel and work together in 1978. In 1979 he traveled to the Sahara Desert in Tunisia to videotape mirages; in 1980–81 to Japan for research of traditional culture and video technology; in 1982 to Ladakh in the Himalayas to observe religious art and ritual in Tibetan Buddhist monasteries; in 1984 to Fiji, South Pacific to document fire walking of the South Indian community in Suva; and in 1987 through the American Southwest to study ancient Native American archeological sites and rock art.

Solo exhibitions, over a dozen since 1973, include a major traveling retrospective at the Los Angeles County Museum of Art (1998), "Bill Viola, Stations," 1996, at the Lannan Foundation, Los Angeles; "Bill Viola, Site of the Unseen," 1994, Centro Cultural/Banco do Brazil, Rio de Janeiro, Brazil; "Bill Viola," 1993, Musée d'art contemporain de Montréal, Montreal, Canada; and "Bill Viola, Unseen Images," 1992, Städtische Kunsthalle, Dusseldorf (traveling). Viola's 1987 retrospective at the Museum of Modern Art, New York was the first video retrospective at that institution.

His installations and videotapes have appeared in over twenty group exhibitions in the United States and Europe since 1972, including the Biennial exhibition at the Whitney Museum of American Art, New York, 1993, 1987 and 1975; "Documenta IX," 1992, and "Documenta VI," 1977, in Kassel, Germany; and "La Biennale di Venezia," 1986 and 1995.

He has received three National Endowment for the Arts Artist Fellowships (1980, 1983, 1989), a John D. Simon Guggenheim Memorial Foundation Fellowship (1985), and the John D. and Catherine T. MacArthur Foundation Award (1989).

Selected Bibliography

Bélisle, Josée (ed.), *Bill Viola*, Musée d'Art Contemporain de Montréal, Montreal, 1993.
London, Barbara (ed.), *Bill Viola: Installations and Videotapes*, Museum of Modern Art, New York, 1987.
"Retrospective Survey," Whitney Museum of American Art, New York, and Los Angeles County Museum of Art, Los Angeles, 1998.
Syring, Marie Luise (ed.), *Bill Viola: Unseen Images*, Städtische Kunstalle Düsseldorf, 1992.
Viola, Bill, *Buried Secrets*, Venice Biennale (catalog), 1995.
Viola, Bill, "Video black — the mortality of the image" in *Illuminating Video: An Essential Guide to Video Art*, Doug Hall and Sally Jo Fifter (eds), Aperture/Bay Area Coalition, 1990, pp. 476–86.

PETER ZAKOSKY

Peter Zakosky (b. 1957, Long Beach) is a native Californian. He was profoundly influenced at the age of five by the last panel of Hieronymus Bosch's *Garden of Earthly Delights* and Bruegel's *Children's Games*. His teenage years were spent uneventfully in Indio, a community in the desert east of Palm Springs, although he and his sister did have two pet monkeys with whom they would occasionally bathe. At some point in his childhood, Zakosky recalls peeling the skin off a dead bird's head to see the skull.

Zakosky studied at the University of California at Riverside (BA, 1979) and the Otis Art Institute (MFA, 1981). Since 1981 his paintings have been presented in over twelve solo exhibitions and forty group shows in the United States, Taiwan, and Japan including "Beyond Appearance," 1994 (traveling); at the Armory Center for the Arts, Pasadena, California; and "Individual Realities in the California Art Scene," 1991, at the Sezon Museum of Art, Tokyo.

He has worked as an art conservator and restorer, studied traditional fresco and painting techniques, continually studies the figure and odd human events and usually makes the frames for his works. Since 1996 he has taught at the Art Center College of Design in Pasadena, California. Zakosky frequently travels, and has extensively visited Asia, the South Pacific, Europe, and Mexico. In 1991 he was artist-in-residence at the Roswell Museum and Art Center in Roswell, New Mexico. Zakosky received a Visual Artist's Fellowship in Painting from the National Endowment for the Arts (1987).

Selected Bibliography

Alter-Gilbert, Gilbert, "A new enigmatism: the artists from beyond appearance" in *Asylum Annual*, 1995, pp. 113–119.
Clothier, Peter, *ARTnews*, February 1990.
Ollman, Leah, "A painter who looks beneath the surface," *Los Angeles Times*, Calendar, 26 January 1990.
Picot, Pierre, "The subversive paintings of Zakosky," *Artweek*, 28 October 1989.
Scarborough, James, "Les payans de Long Beach," *Visions*, Summer 1992.
Zakosky, Peter, "Duality — a perceptual problem," *Psychological Perspectives*, Issue 29, 1994.

Acknowledgments

A veritable cadre of people deserve my deepest gratitude for the support and cooperation they provided in the writing of this book. (If any name has inadvertently been omitted, I beg indulgence!)

First and foremost, the artists who supplied their time, information, made requested arrangements, and endured my questions.

I received a great deal of cooperation from galleries and their staffs including Rhona Edelbaum from Ruth Bloom Gallery (now defunct), Christine Wachter from Blum/Helman Gallery (also defunct), Craig Krull, Rosamund Felsen, Robert Berman, Burnett Miller and his assistant Michele Nelson, Kimberly Davis at L.A. Louver, Dudley del Balso, Lynn Sharpless at Angles, Frank Lloyd, who has since left Garth Clark and ventured out on his own, Steven Fuller at John Weber Gallery, Kristina Van Kirk at Ace Contemporary Exhibitions, Margo Leavin, Jennifer Dunlap and Anne Pedersen at Margo Leavin Gallery, Kirsten Biller at Shoshana Wayne Gallery, Dan Saxon, Eleana Del Rio at Koplin Gallery, Jay Gorney, Pat Poncy for Ed Ruscha, Dianna Pescar for Bill Viola and James Pedersen at Feature.

Robert Byer performed yeoman work in the preparation of many artist profiles. Roella Hsieh Louie always supported time away from my 'day job' to get the writing done. Nevill Drury is the most patient and understanding publisher alive. The biggest debt of gratitude is owed to my wife Robbi, who did proofreading, made editorial suggestions and, along with Kiko, Jake, Julia, and Guy, generally endured my moods and what may have seemed like the longest book project ever undertaken.

All images are courtesy of the individual artists, unless otherwise noted.

The following books are suggested reading for obtaining a better understanding of the dynamics of art in Los Angeles. Additionally, there are many excellent exhibition catalogs and books listed in the bibliographies of the individual artists.

Reyner Banham, *Los Angeles: The Architecture of Four Ecologies*, Penguin Books, New York, 1971.

Mike Davis, *City of Quartz, Excavating the Future in Los Angeles*, Vintage Books, New York, 1992.

Michael J. Dear, H. Eric Schockman, and Greg Hise (eds), *Rethinking LA*, Sage Publications, Los Angeles, 1996.

Helter Skelter: LA Art in the 1990s, Museum of Contemporary Art, Los Angeles, 1992.

Mary Jane Jacob, and David Brenson, *Culture in Action*, BayPress, Seattle, Washington, 1995.

Christopher Knight, *Last Chance for Eden — Selected Art Criticism 1979–1994*, Art Issues Press, Los Angeles, 1995.

Suzanne Lacey, *Mapping the Terrain — New Genres in Public Art*, BayPress, Seattle, Washington, 1995.

Carey McWilliams, *Southern California: An Island on the Land*, Peregrine Smith Books, Salt Lake City, Utah, 1973.

David Reid (ed.), *Sex, Death and God in LA*, University of California Press, Berkeley, 1994.

Ralph Rugoff, *Circus Americanus*, Verso, New York, 1995.